made in manchester

First published in the United Kingdom in 2004 by
Dewi Lewis Media Ltd.
8, Broomfield Road
Heaton Moor
Stockport SK4 4ND
England

wwww.dewilewismedia.com

Photographs & texts: © 2004 Eamonn & James Clarke
For this edition: © 2004 Dewi Lewis Media Ltd.

ISBN: 0-9546843-0-3

Printed in Italy

A selection of limited edition photographic prints signed by the photographers is available.
For further information visit our web site – wwww.dewilewismedia.com

David Beckham: Made in Manchester is an unofficial record of David Beckham's time in Manchester.
It is not connected with, or endorsed in any way by David Beckham, his representatives, or any
individual, organisation or company connected with him or by Manchester United Football Club
or by Real Madrid Football Club.

david BECKHAM: made in manchester
an unofficial photographic record

Eamonn & James Clarke

dewi lewis media ltd

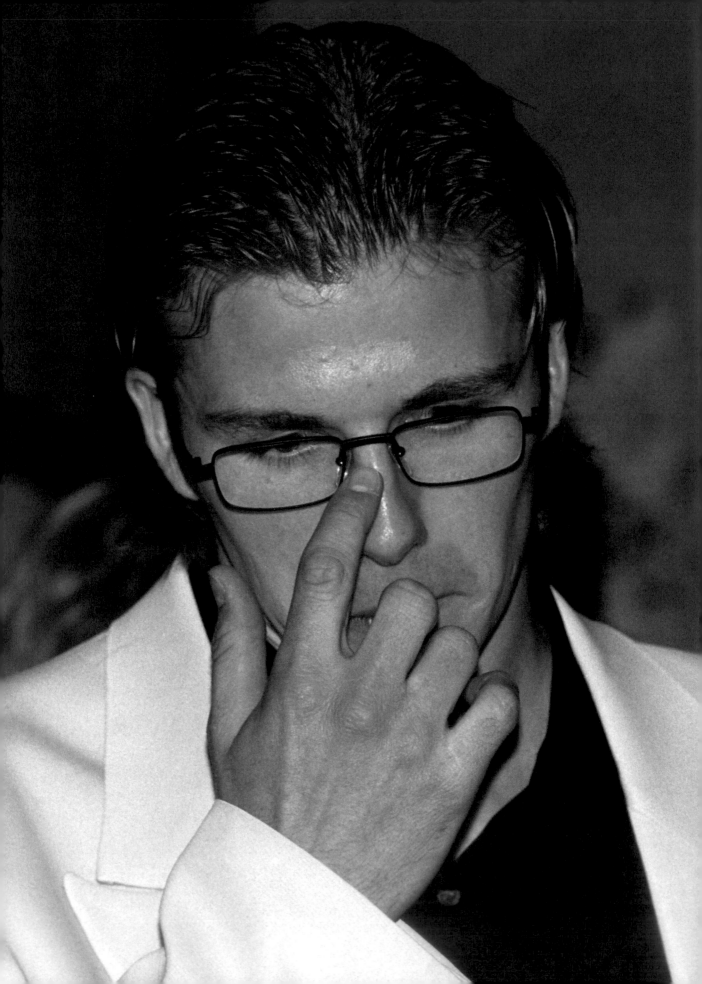

MADE IN MANCHESTER

It seems strange how it all began. In the late 1980s I was working at Manchester's Palace Theatre as an usher. My sister gave me a camera and so I started taking pictures. That was it. I enjoyed it and after a while I saved up to buy a better quality SLR camera. At the time, one of the girls who worked with me went to a place called Counter Image, which ran photography courses and so I enrolled for a six-week, Tuesday night class.

And basically that was where I first learnt to take pictures. I then went on to do a City & Guilds at Chorlton College, one night a week. It taught all the technical stuff you needed. I quit my job at the theatre and became a studio assistant for a year, basically working on catalogue shots – one of the most boring jobs in the world. But alongside that I'd started to build up quite a nice portfolio I'd done around town. I applied for a place on a year's full-time NCTJ course in photojournalism at Sheffield, and managed to get in.

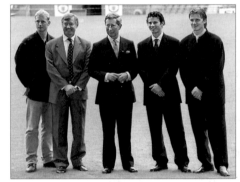

September 1996: David May, Sir Alex Ferguson, Ryan Giggs and David Beckham meet HRH Prince Charles.

I came back to Manchester in 1991. There were literally no jobs in newspapers and so I free-lanced. Because I'd worked in the theatre for seven years, the first thing I did was to go along to the Palace. I managed to get on their photocall list, and eventually to do some of their PR photos. From there, through the theatre and through people I knew, I started doing jobs for *City Life*, Manchester's 'what's on' magazine – at £15 a picture.

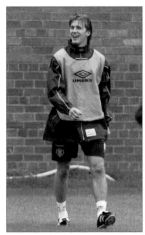

September 1996. In training.

I remember having to borrow money from my two younger brothers to buy film; I was so skint, there was just so little money in photography. One thing that I tried was a deal with the local paper, *Manchester Metro News*, for a concert by Bananarama. No staff photographer really likes to work nights and so I agreed to give the paper a free photo if I could take their concert pass. I could then sell the photos on afterwards, which worked quite well.

After a while I started to get more involved in photographing celebrities. The first big break at national level was when James and I photographed Mick Hucknall as he was leaving the Haçienda club with two women at four o'clock in the morning.

This was in 1993. We knew the head doorman at the club, and had gone in for a late drink. And there was Mick Hucknall leaving. We knew his car and went over. He thought I was on my own, and he came out with a very memorable and rather strange line – "You don't want to upset me, I have really powerful feet". 'Bizarre', the gossip column in *The Sun*, ran a full page using his quote as their headline.

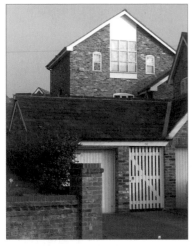

At this time, I was photographing anything to see if I could sell it. I became good friends with a freelance photographer on the *Manchester Evening News* diary, and eventually I sort of slipped in as his replacement. I had a great arrangement with the *MEN* which saved them money, but also meant that I kept the copyright on everything – probably the best thing I ever did.

At the beginning we kept all our press cuttings – for about the first four years. But after a while it got to the point where there were just too many, so that we would have ended up spending more time down at WH Smith looking for things in magazines than actually out and about taking pictures.

David Beckham's former house in Worsley, Manchester.

James worked abroad most of the year for some ten years, and only took photos when he was back in the winter. Winter is harder because you get the worst light, but to balance that you tend to find more celebs. He became full-time recently and stopped going to Greece. There are lots of practical benefits of working together. If you're photographing someone who's not so keen on being photographed, then if he sees you, he'll tend to turn away in the opposite direction. And if you know that, you have the second photographer on the

March, 1997. At a charity auction with Ryan Giggs, Dave Gardner and Tim Healey, star of 'Auf Weidersehen Pet'.

other side. There's also safety in numbers. And of course, there's always a back door to every building, and celebs will often use it. So we can cover both doors.

It's not a glamorous job. There's a lot of hanging around. We may get into a VIP party and enjoy a drink, but when that party ends, at say two in the morning, we have to go home and work. People think it's easy with digital cameras, but it's not. We'll usually need three computers on the go, as we do full sets of pictures, edit them, then wire them to all the newspapers. It can be 6.30am or 7.00am by the

time we get to bed. We used to have to develop the films and send them in, which was even worse. But then the negative was the archive. Now you have to archive everything that night, otherwise it's gone forever. With it being digital it has to be transferred to computer, backed up onto another computer, and then, for added safety, backed up onto another hard disk.

In the early years Mick Hucknall was the biggest celebrity in Manchester, followed by Take That, and Ryan Giggs. Giggs was the football superstar. But then David Beckham knocked him off the celebrity pedestal. The very first photograph I took of Beckham was purely because I was waiting for Giggs – out of boredom really – these are the photographs with Julie Killelea early in the book. I was just waiting for Giggs and I thought, I'll drop a couple of frames. It just goes to show.

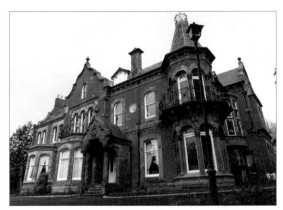

The house in Alderley Edge, Cheshire, where David Beckham had an apartment.

David Beckham has a good memory for photographers. If you're rude to him once, he'll remember. That's it, it's gone. Once we had started to photograph him seriously, we never went to his house. We'd heard from another footballer how much he hated the press going there – that it was the one thing that would really wind him up. When David Beckham did say no, we walked away whenever we could. We always hoped that he would think better of us for that. That's perhaps why there were rumours that on occasions he had rung us. It wasn't true, but strangely some people can't accept that a bit of civility can help in other ways. The reality though is that Manchester is a small city. The more hours we put in, the harder we work, the longer we stand outside nightclubs, the 'luckier' we seem to get!

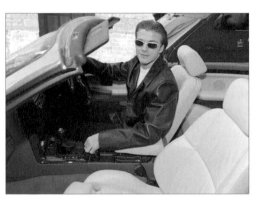

April 1997. David's burgeoning interest in cars.

Sometimes you have to give up on massive opportunities. Last year, when it was Victoria's birthday, they'd all gone to a bar/restaurant called the Living Room. Both families were there, including the kids. We were in position, with James at the front and me at the back. He came out at the back with his minder and said, please, can you not do it tonight. I said fine, and just walked away. As I was leaving, the car drew up behind me, the window came down and he said, thanks for that. Literally within days we had other good pictures of him.

One of our biggest stories was towards the end of his time in Manchester – after the boot-kicking incident that left him with a cut above his eye. James spotted him in Manchester and asked if he was okay to do pictures, given what had happened.

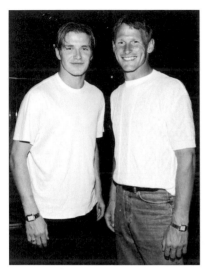

July 1997. With Teddy Sheringham.

James then said that he was just going to shoot up and down King Street. That was it. David Beckham didn't say yes or no – he didn't avoid us, nor did he do anything to particularly help us. We must have got hundreds of frames.

That morning he had been photographed through his car window as he left for training. It was a good photograph – one that would normally have been 'picture of the day'. But after training he didn't go home, he went into town. And so they had pictures of him leaving home at ten, whilst ours were taken between two and three in the afternoon. The papers didn't even see ours until four. What happens is that you wire the pictures and say, look we're sending you a great photo of Beckham with his cut eye. Of course, they said they'd already got it in the morning through the PA (Press Association) and through the staff photographers at the house – the photograph through the car window. We just said – we think you should take a look – and they did.

When you know you've got a great photo like that one, you ideally want to get away as quickly as possible. But you have to stay around to make sure no-one else is there. If another photographer turns up, then he could do something completely different, and get a better picture. You always have to be in the position to know how special the photographs that you're offering to the papers are. And so you have to wait until David Beckham leaves. You withdraw, yet you have to stay where you can see him – at the same time hiding in case other photographers are looking out for you – that's the problem.

May 2003. Arriving at the Living Room for a team celebration after the final game of the season.

David spent about an hour in the city centre that day – the longest hour of our lives! It was terrible – we were very lucky though. There had been a pack of maybe fifteen or twenty photographers as well as TV crew at the house. Thankfully they were all so convinced that he wouldn't go anywhere other than training, that they had all stayed there. The rumour was that someone had rung us – I wish they had. But it was a good day – at least in most ways.

Professionally it was a great picture to get, but as United fans it was a sad day for us really, because we knew pretty much as soon as we'd seen the photo that it was a turning point – we couldn't imagine that he'd stay after that. And of course there was all the media speculation that he was courting attention, trying to get his point across. Who knows though, he might just have been out shopping. After the event he might have been glad about it. It certainly seemed to make his leaving a lot easier, even for the fans who in the end seemed to just accept the move, and never harboured any resentment – something very unusual when a player leaves a club to join a rival team.

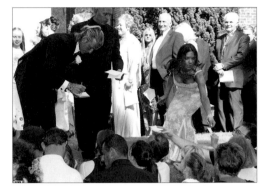

July 2003. Signing autographs at the wedding of Davinia Taylor and Dave Gardner in Chelford, Cheshire.

People are always asking us how much we can get paid for a photograph. It varies massively – between the low hundreds to the medium thousands. Our agencies approach the magazines, but we always contact the papers ourselves – both tabloids and broadsheets. With this photo we made it to the front page of eleven national newspapers. We've done even better since on another photograph – one of Rio Ferdinand – taken completely by fluke, on the day that he missed the drugs test, and with that we got twelve front pages.

It now seems that the newspapers are trying to turn Cristiano Ronaldo into the next David Beckham – I just don't see it. We've actually done a couple of nice features in which we've got Ronaldo in identical clothes to Beckham. We even photographed the Turkish footballer Alpay (the player who was involved in an incident with David Beckham during the Turkey/England Euro 2004 qualifier), dressed like Beckham, walking around Manchester with the Beckham watch, and the Beckham hat.

If you search for another David Beckham you won't find one. To get that balance between the pop star life, the great footballer, the role of England Captain, the style – all these things together – is almost certainly impossible.

David Beckham was lucky, because he was never a replacement for someone else. Ryan Giggs was always seen as the next George Best – and always compared to Best. David Beckham was never really compared to anyone. He was able to become his own person.

May 2nd, 1975
Born in Leytonstone

May 2nd, 1988
Signs as a schoolboy with Manchester United

July 8th, 1991
Joins Manchester United as a trainee

September 23rd, 1992
Manchester United first team debut

January 22nd, 1993
Signs as a professional with Manchester United

August 19th, 1995
Scores his first Premiership goal

September 1st, 1996
Full England international debut

July 4th, 1999
Marries Victoria Adams

November 15th, 2000
Captains England for the first time

June 13th, 2003
Awarded the OBE

June 30th, 2003
Manchester United contract expires

July 1st, 2003
Signs for Real Madrid

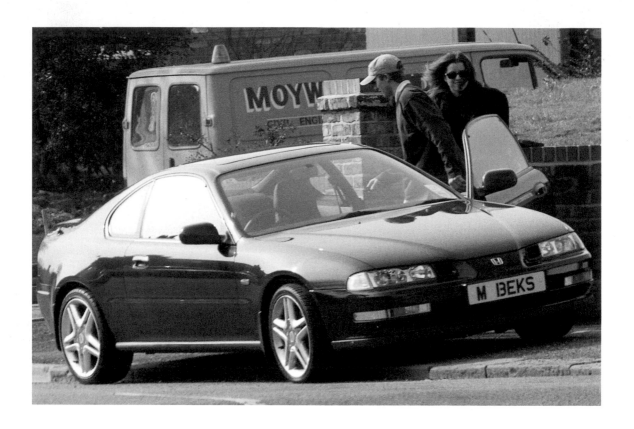

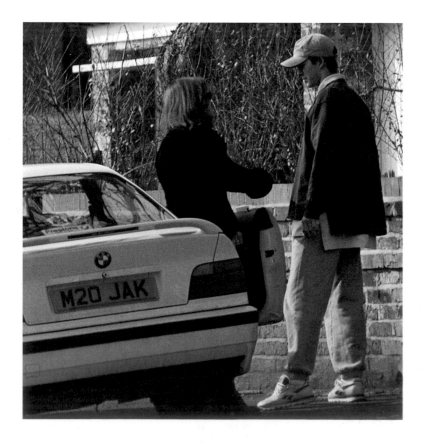

above and left
18th March, 1996.
In front of his house on
Hazelhurst Road, Worsley,
with then girlfriend Julie
Killelea. Ryan Giggs' house
was just behind, on the same
estate, and I was really in the
area to try to photograph
him. The Honda Civic above
was David Beckham's first
reasonable car, but it wasn't
long before he was on to
more expensive models.

right
26th March, 1996.
With Julie Killelea at the
première of the film
Broken Arrow.

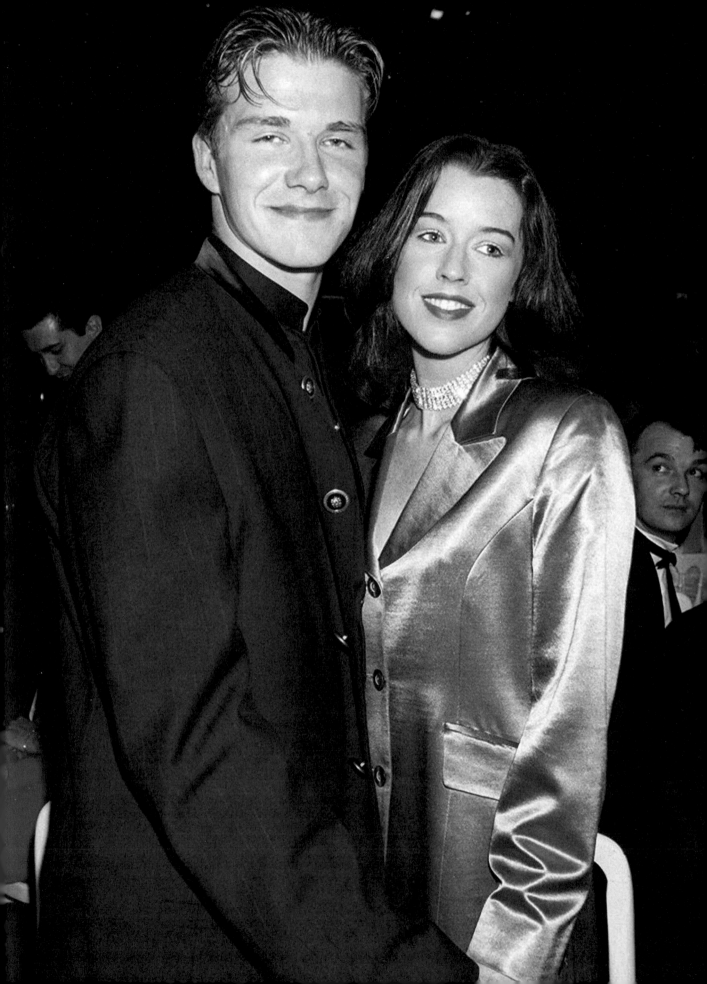

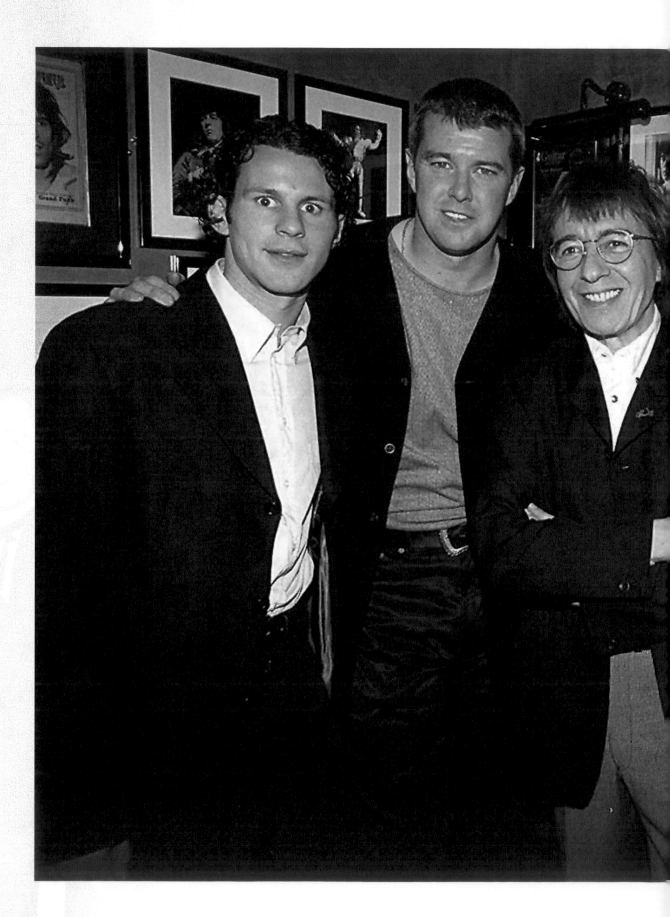

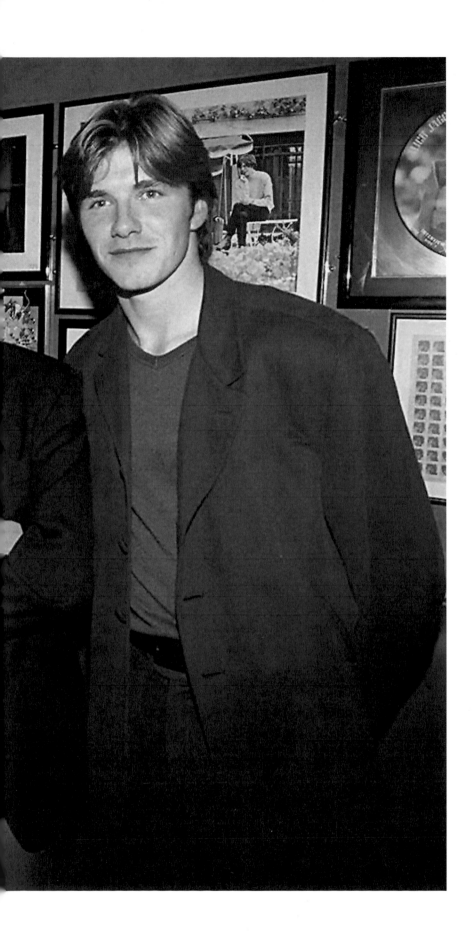

11th November, 1996.
Ryan Giggs, Gary
Pallister, Bill Wyman
and David Beckham at
the opening of Sticky
Fingers restaurant. In
many of the photos
used by the press
around this time David
Beckham was cropped
off, as the other players
alongside him were
more famous.

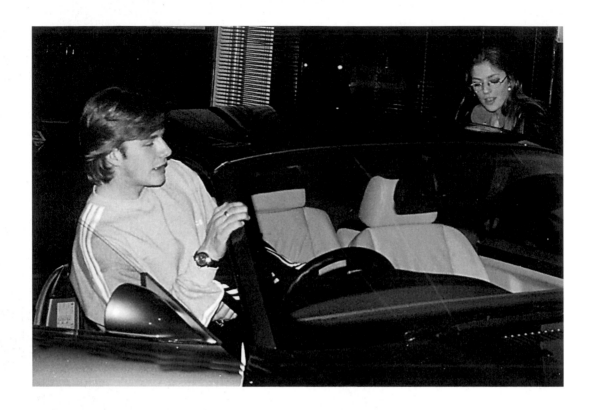

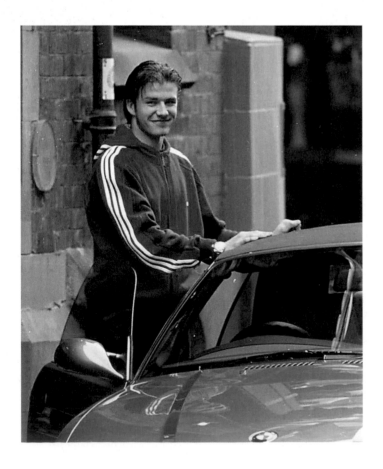

top
22nd January, 1997.
Getting into his BMW, with
Stephanie Lyra, an Italian
student who worked as a
waitress at the restaurant
Est Est Est.

left
Outside Harper's restaurant,
opposite Est Est Est, waiting
for Stephanie.

right
9th January, 1997. At the opening of
the NYNEX Cinema, Manchester.

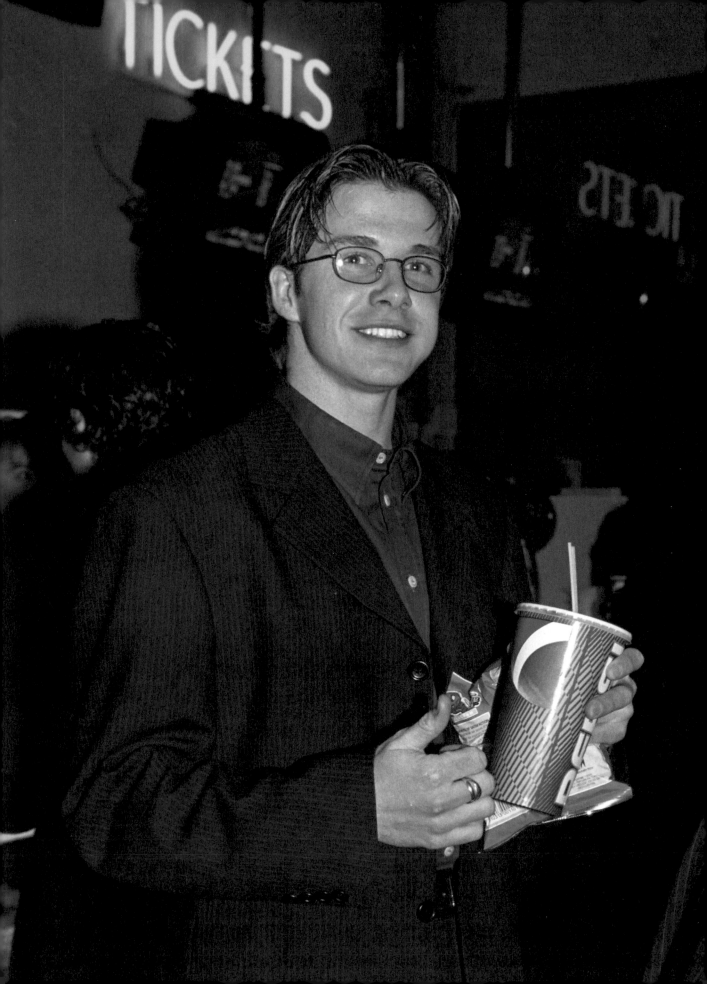

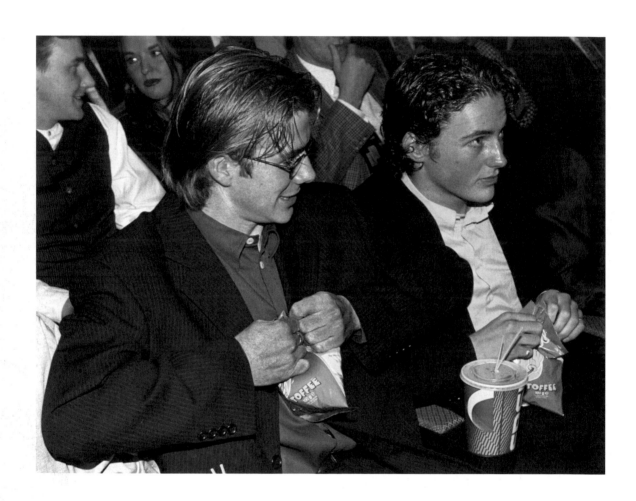

above and right
9th January, 1997. The opening of the NYNEX Cinema, Manchester.
David Beckham turned up with his best mate and ex-United trainee, Dave Gardner, who now runs a sports management company, along with Sir Alex Ferguson's son, Jason. Beckham was wearing clear glass spectacles, though he told a journalist that night that he needed lenses. I was able to go down the aisle and photograph him close up. These days you'd only be allowed to snap them as they went in, and we'd never get into the cinema.

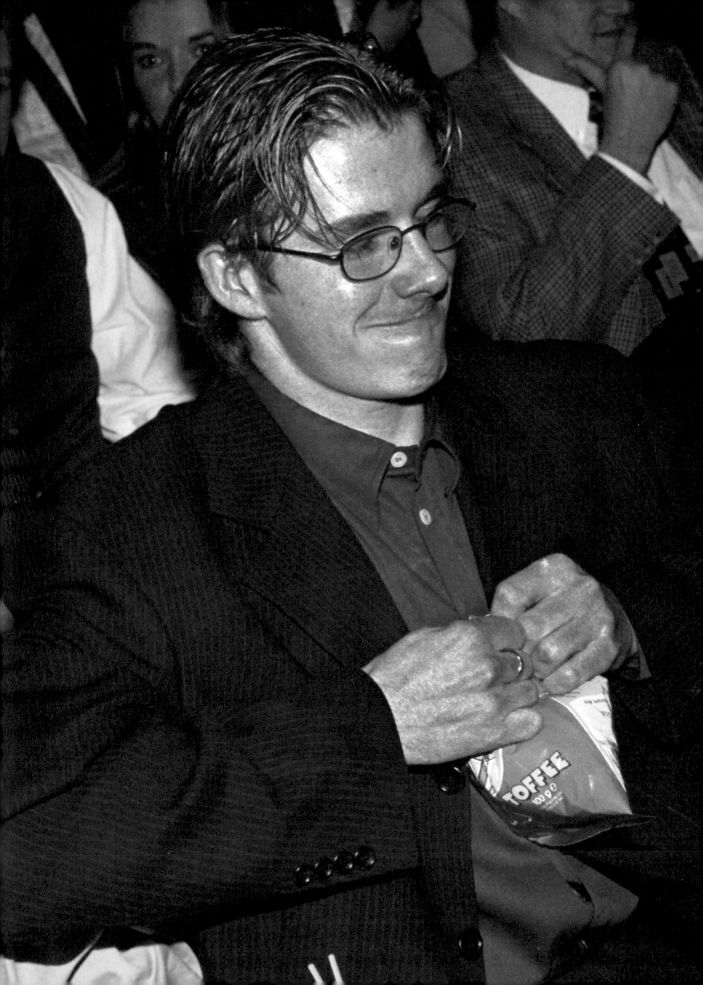

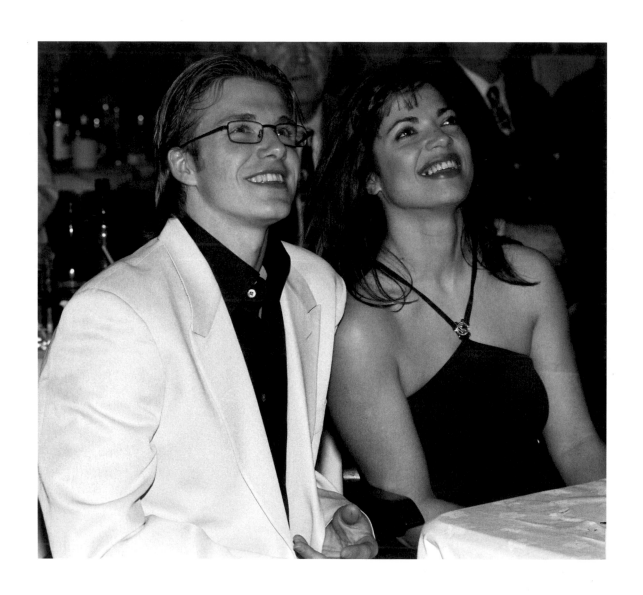

11th March, 1997
Charity Auction at Sticky Fingers.
Talking with TV presenter Jenny Powell at a charity auction in aid of the Nordoff-Robbins Music Therapy Trust.

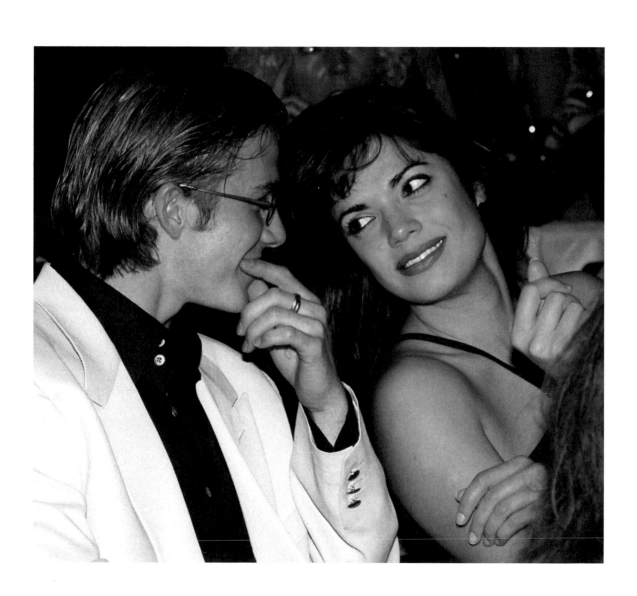

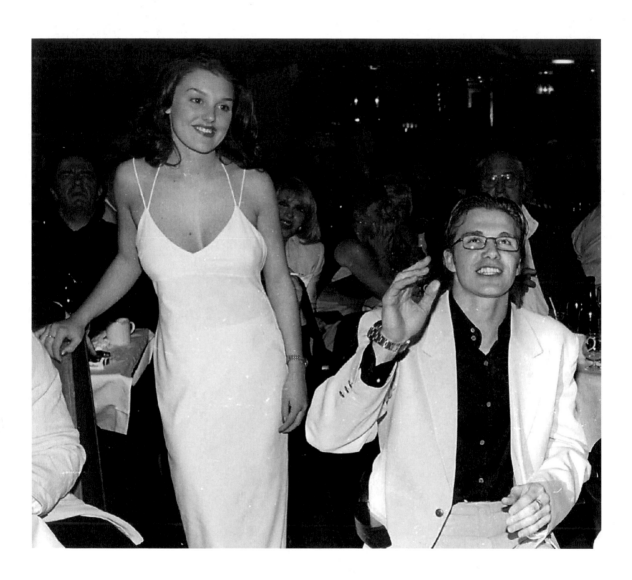

At the Charity Auction.
above: Christa Kemp (*in the white dress*), was helping at the event.
right: Talking to *Manchester Evening News* journalist Andy Spinoza.

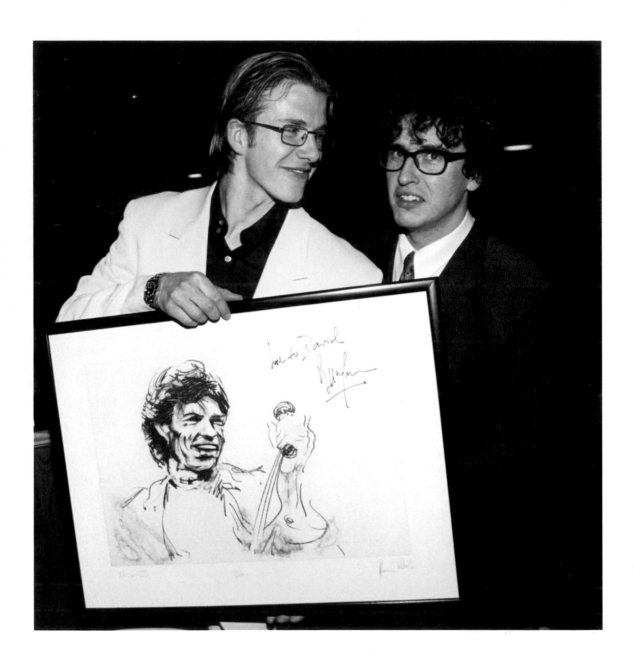

11th March, 1997. Charity Auction.
David bought a signed print of Mick Jagger at the auction. The white suit and the glasses show his taste for looking different, but what got the photograph into the papers was that he wasn't wearing any socks. Steve Coogan (with Beckham in photo above) was pulling mock serious faces as we photographed but David Beckham was very natural and didn't really pose.

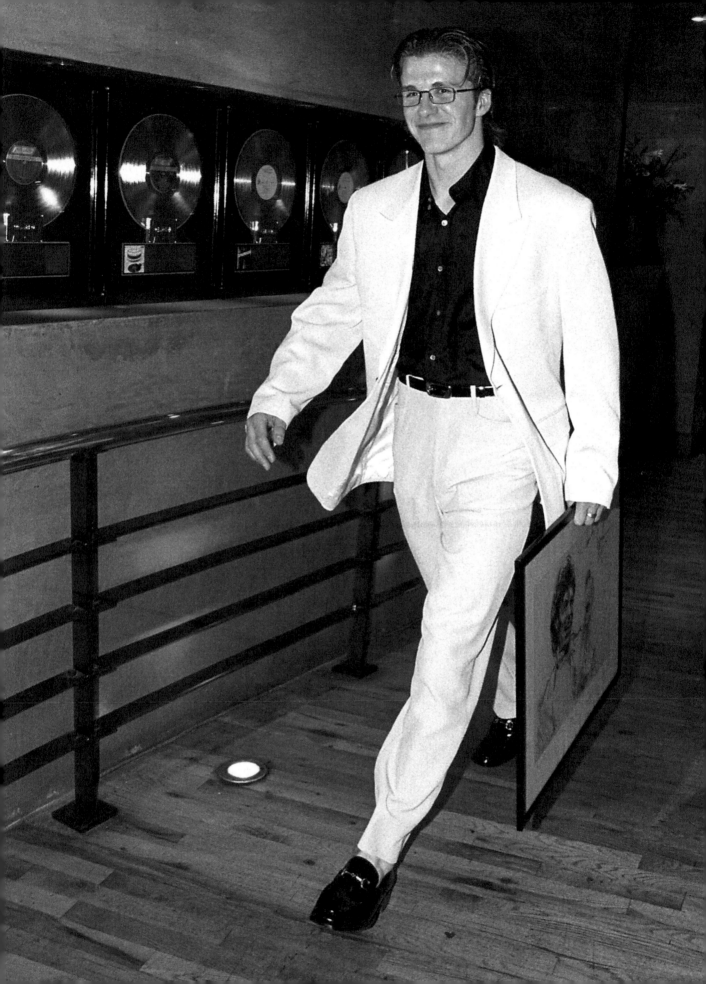

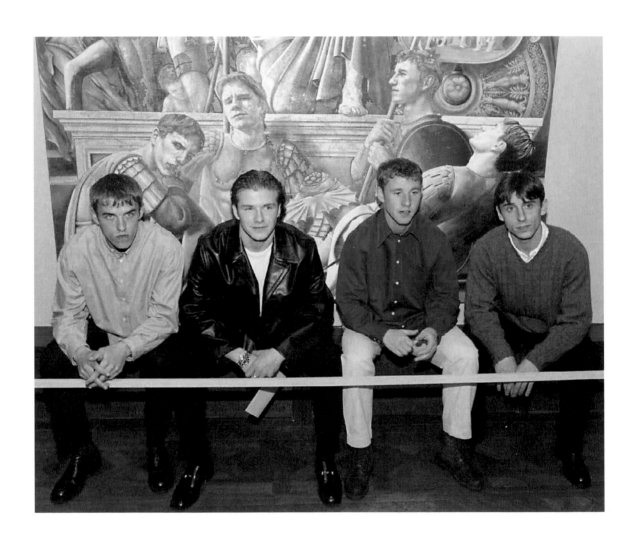

15th April, 1997

The Art of the Game, by Manchester artist Michael Brown, was unveiled at Manchester City Art Gallery. Sir Alex Ferguson, Eric Cantona, Nicky Butt, Paul Scholes, Phil Neville, Gary Neville and David Beckham were all there to publicise and support the event.

The Art of the Game is reproduced by kind permission of Michael Brown

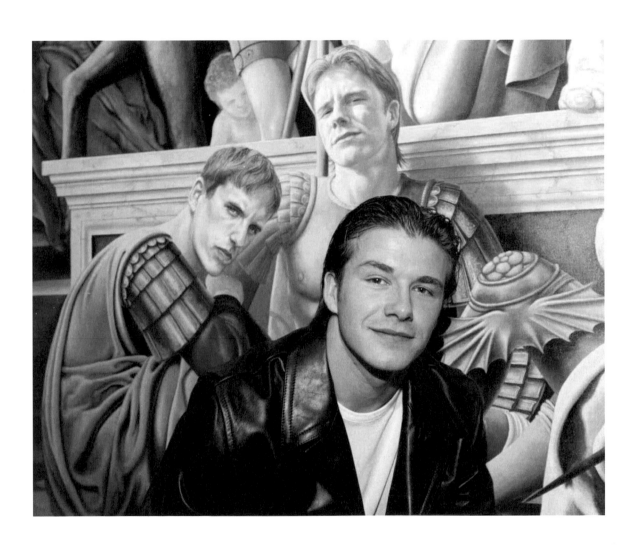

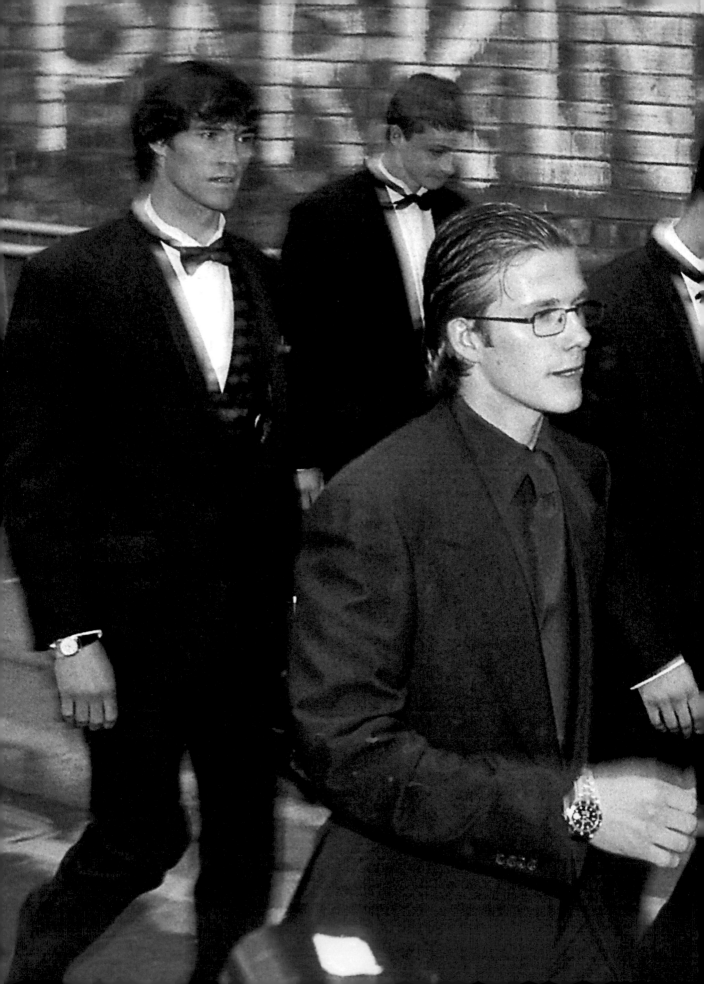

4th April, 1998
Manchester United had just won the Championship. Here the
players are on their way to the Prince's Trust concert at the
Opera House, where the Spice Girls were performing. The
players had just used the Old Grapes pub next door to get
changed into black dress suits – apart from David that is, who
wore purple.

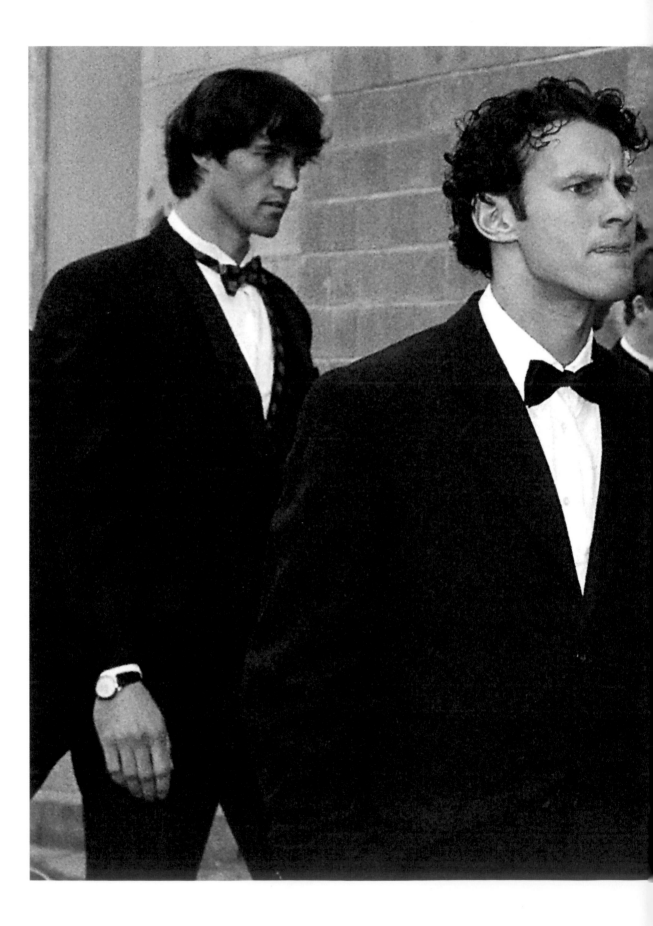

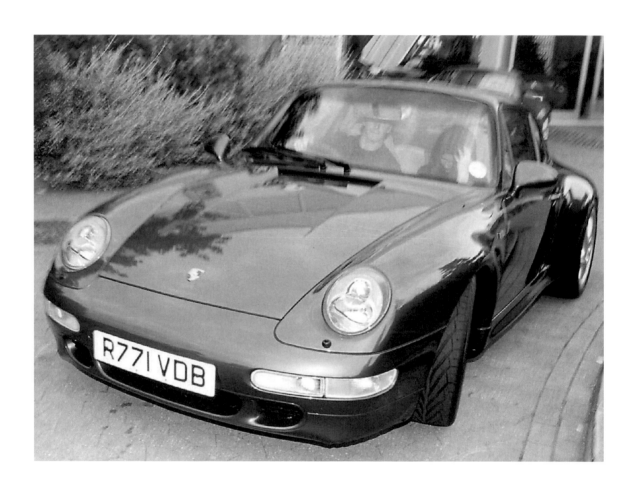

4th August, 1997
David had just traded in his BMW and bought a blue Porsche for around £70,000, from Stratstone's dealership in Wilmslow. I'd had a tip-off and was at the garage when he came out. He left with Victoria next to him. It was the first time we had seen the registration number VDB, but the irony was that it was just a block plate number from Stratstone's and didn't mean Victoria David Beckham, as the papers thought. David said it was just coincidence.

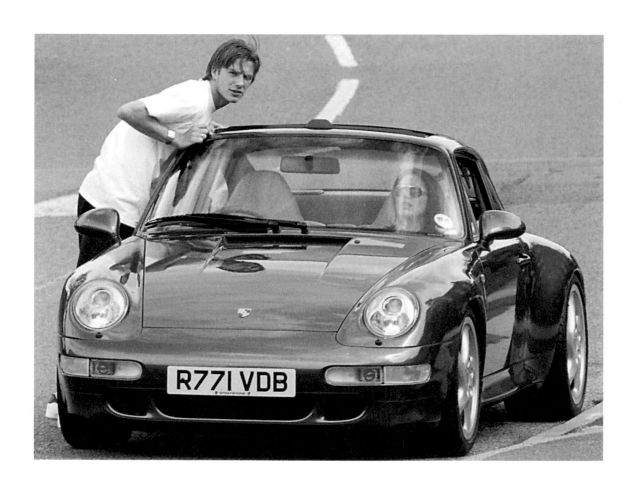

The next day, word got out about his new car. After he took it out for a spin, he returned to find a crowd of photographers outside his house. The picture shows him stopping up the road to talk through the sun roof to Victoria. Then they sped off.

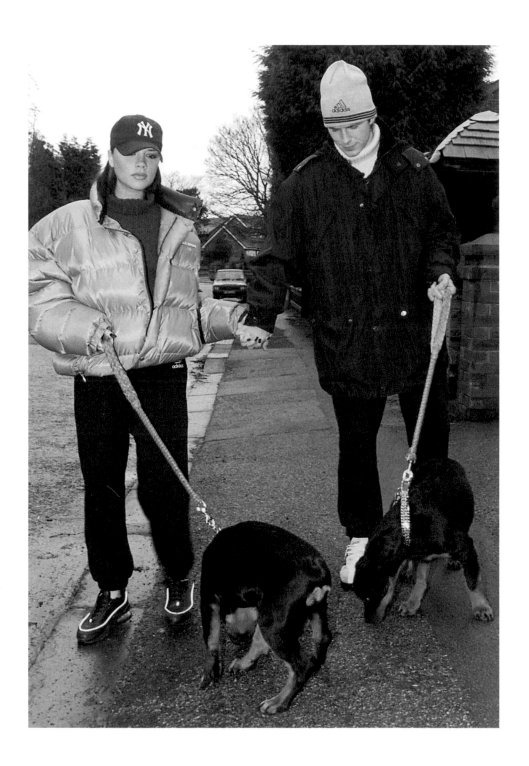

27th December, 1997
Walking his two Rottweilers, Puffy and Snoop, in Worsley (the dog's names show his interest in hip-hop music). I bent down to stroke the dogs and David jokingly said: 'Don't do that, we're training them to attack photographers'.

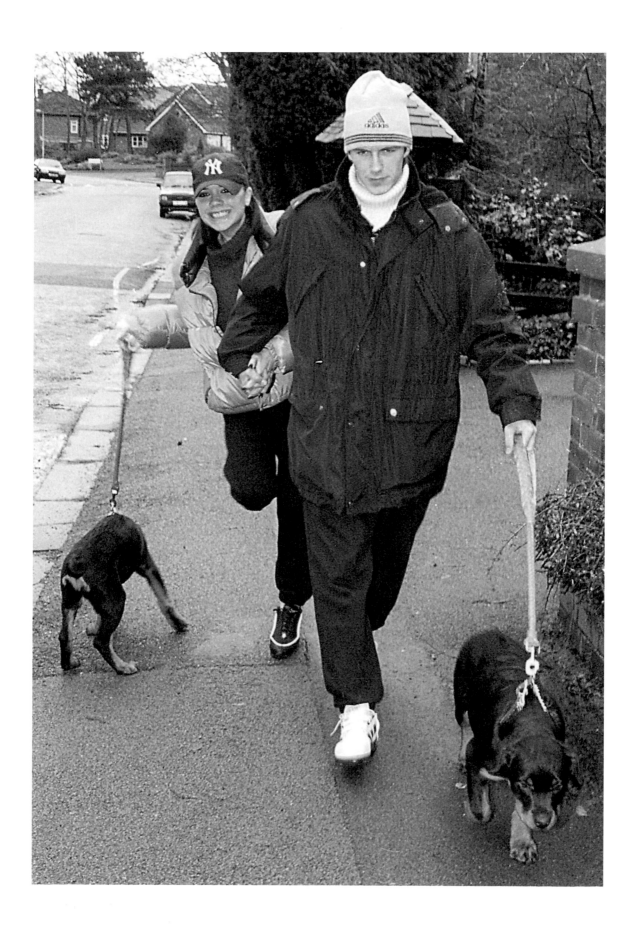

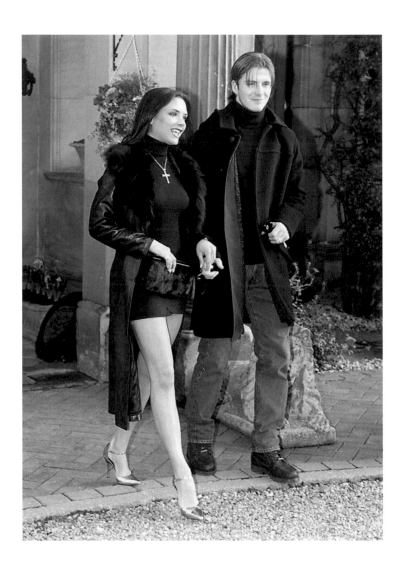

25th January, 1998
Victoria and David's engagement at the Rookery Hall Hotel, Cheshire.
The media was officially invited, but some journalists seemed most
interested in their discovery that his car tax disc was out of date.

following page; leaving the Rookery Hall Hotel.

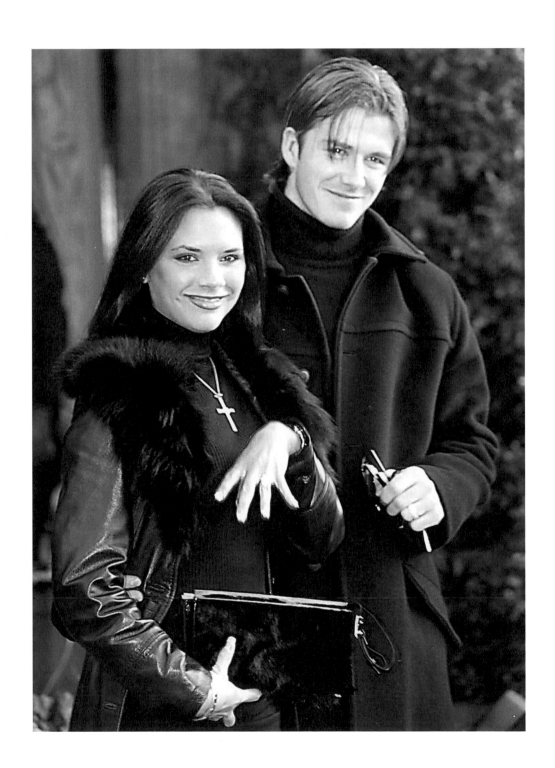

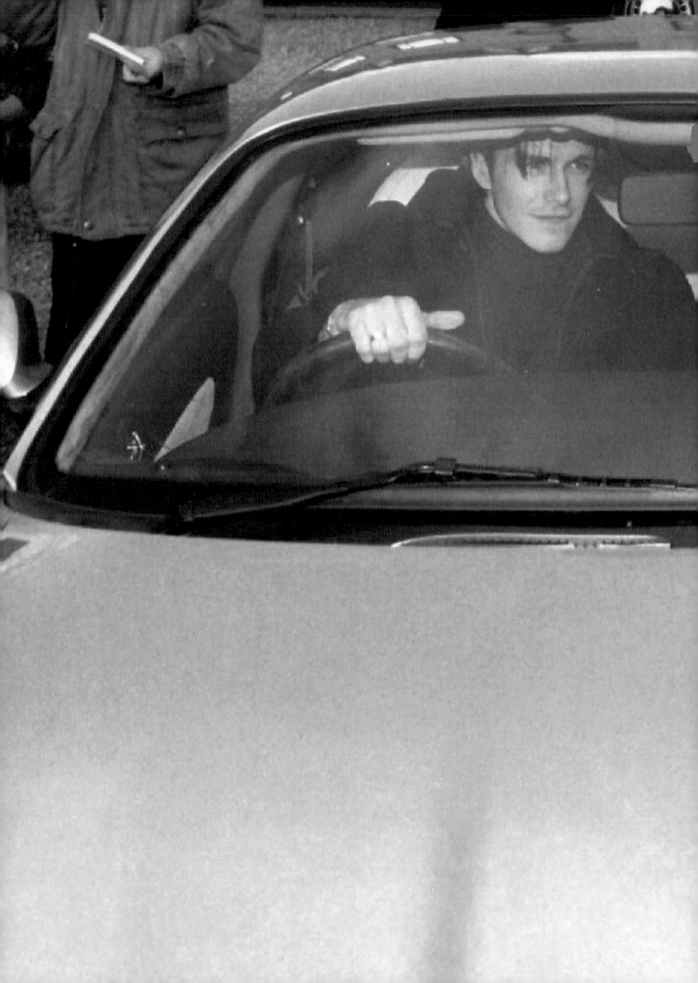

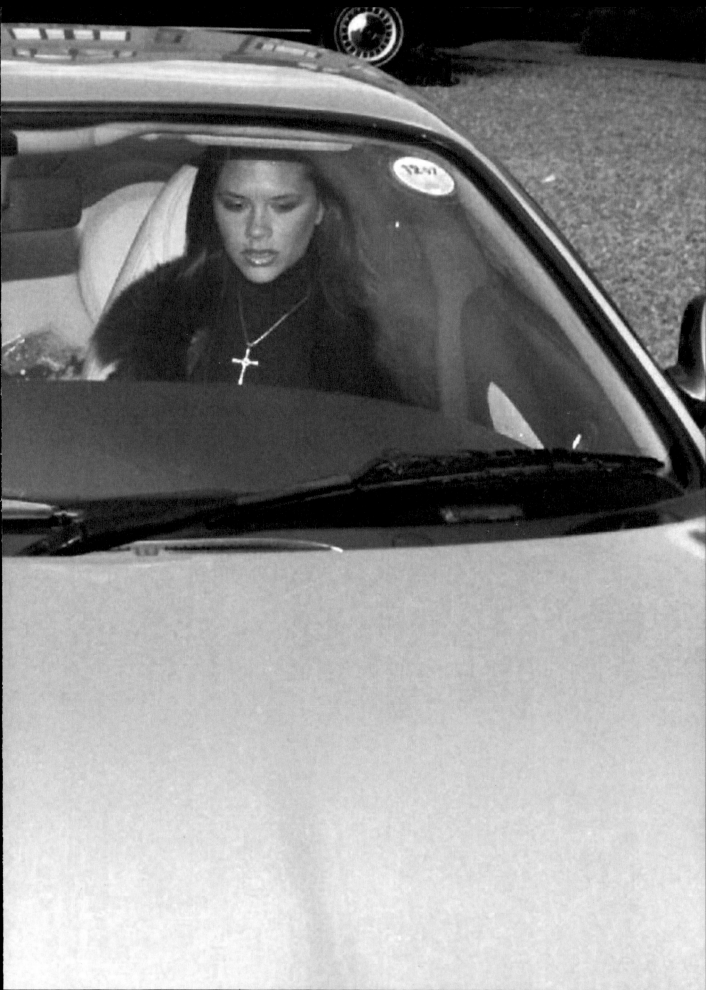

5th February, 1998
At the announcement of David Beckham's
sponsorship deal with Adidas

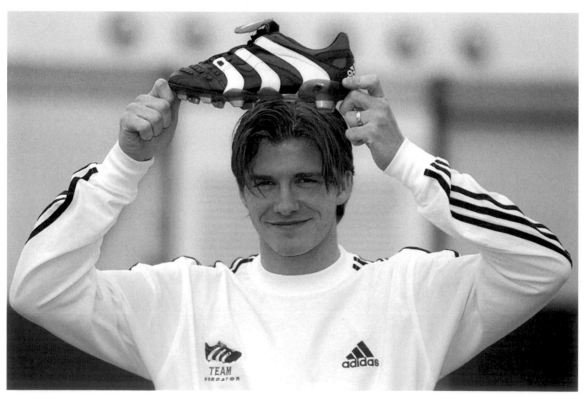

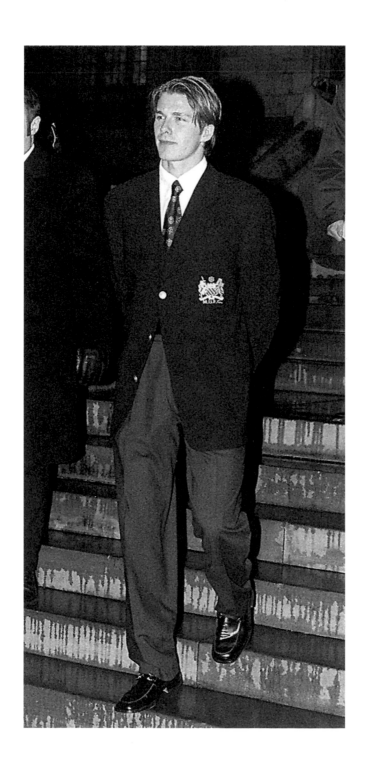

6th February, 1998
Munich Air Crash Service, Manchester Cathedral.
Walking down the steps of the cathedral after the service.

14th February, 1998. Valentine's Night.
David and Victoria arrived at the Midland Hotel for a romantic dinner. They weren't too happy that we were there, but we do always ask and eventually he half-smiled for us.

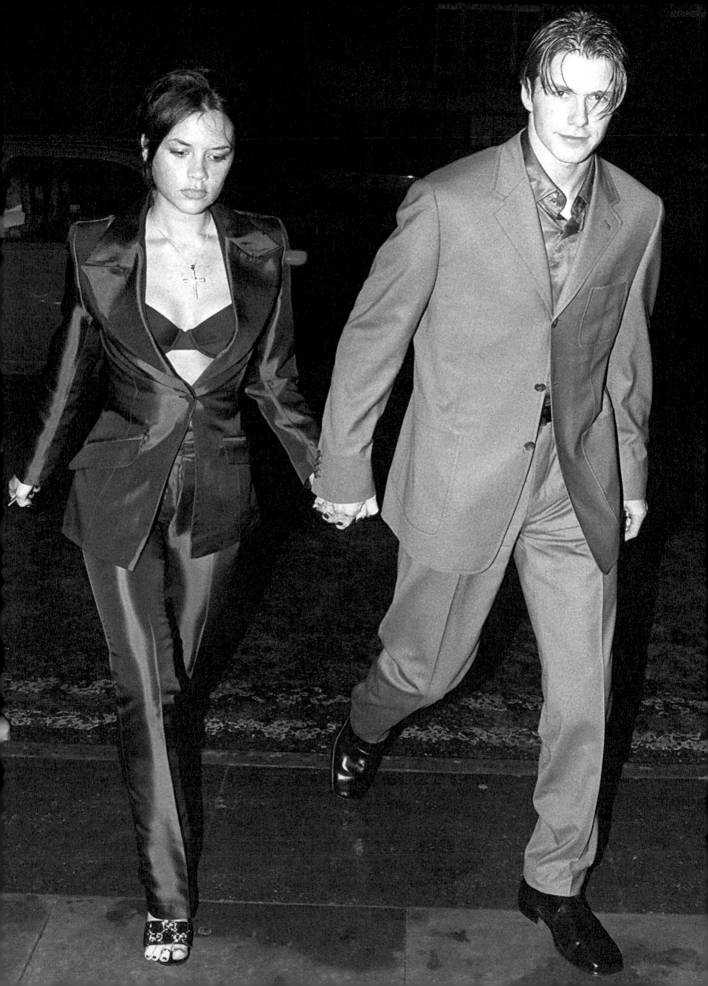

6th April, 1998
United had beaten Blackburn Rovers 3-1 that night. It was a Monday and the Spice Girls had played a concert at the MEN Arena, as part of a week-long series of shows in Manchester. They held an after-show party at Mash and Air. Notice David's club blazer, perhaps he didn't have time to put on anything more unusual.

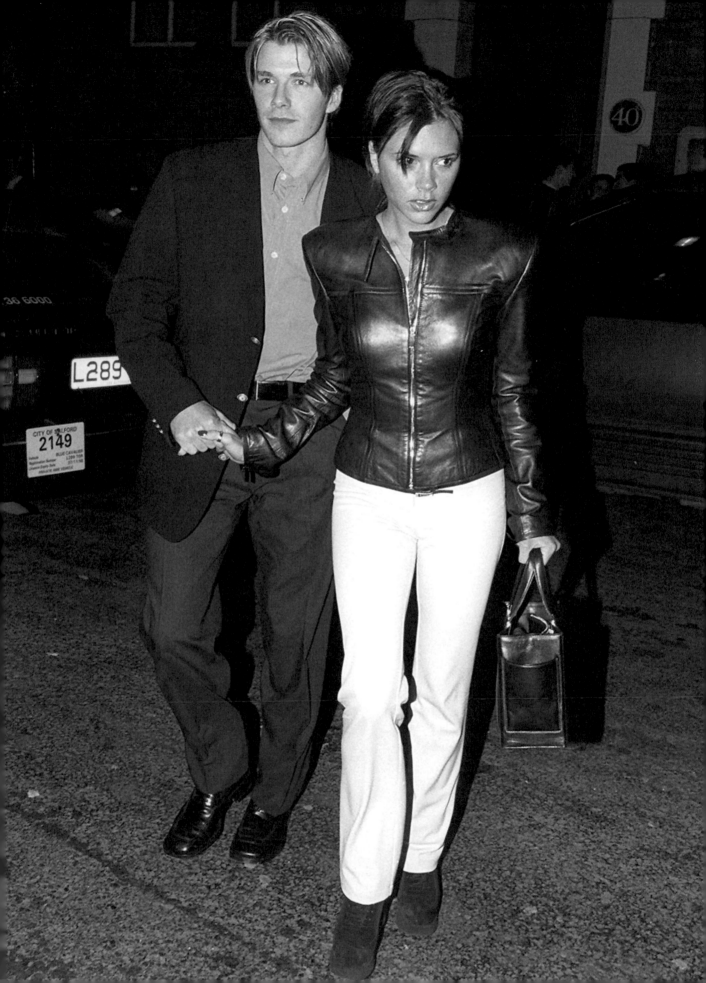

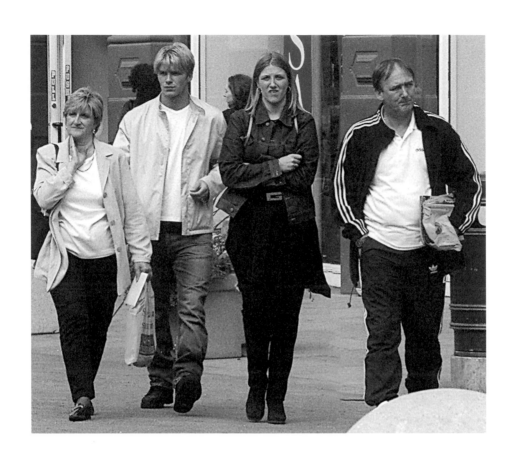

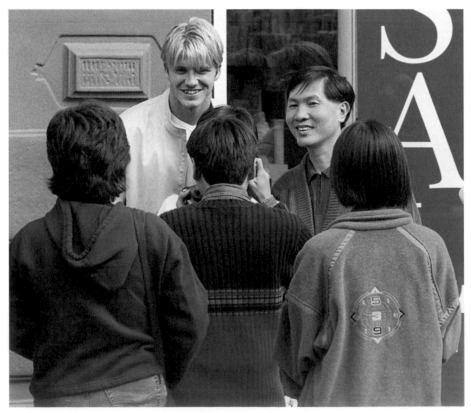

left
15th July, 1998
This was the first time we'd seen him with dyed blonde hair. He was out shopping in Manchester with mum Sandra, dad Ted and his sister, in St Ann's Square. It was also an early sign of Beckham-mania. We noticed that he was being mobbed by all types of people, and a lot of girls were asking him for his autograph. He was happy to sign for anyone who asked.

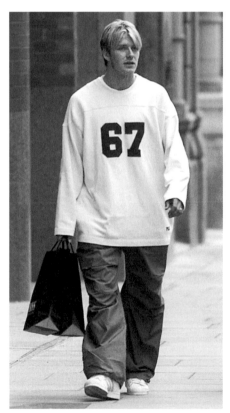

top and bottom right
23rd July, 1998
Shopping on King Street, Manchester. You can see that the fashions are beginning to change. It's Beckham goes baggy – and the first signs of a wispy beard are there.

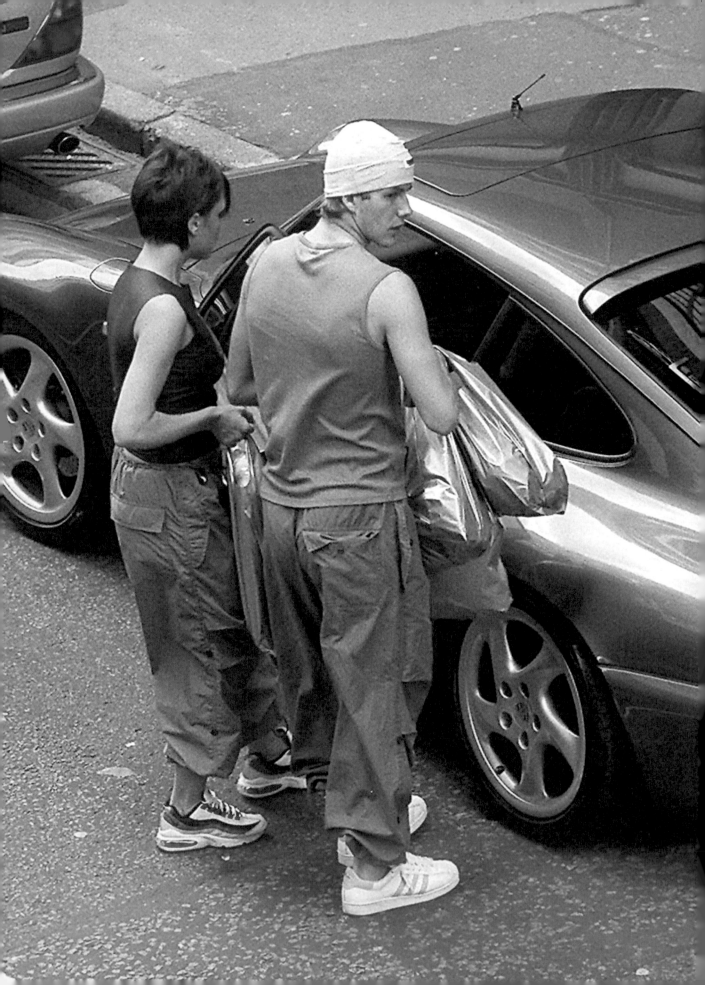

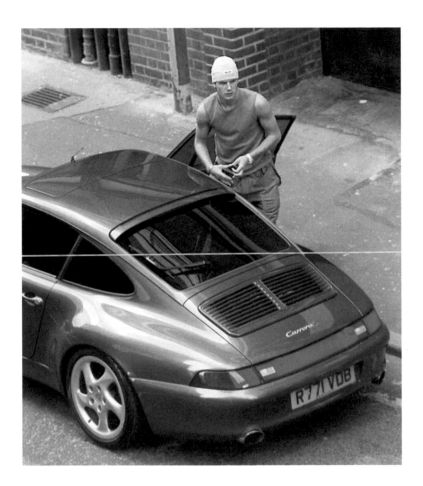

7th September, 1998
This was the first photograph we had taken of Victoria pregnant (*left*). They
had parked at the back of Kendals department store, and I photographed
them from the first floor of the store car park, looking down on them. By
now they were becoming much more wary of photographers.

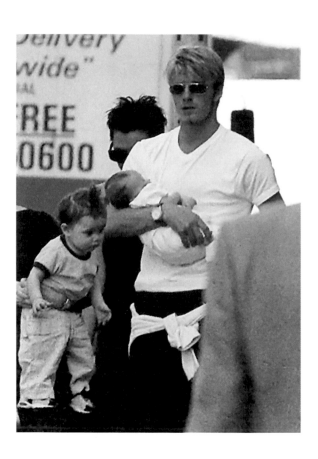

left
15th April, 1999
This was the first time that Brooklyn was seen in Manchester. Typically for new parents they were very protective of the baby.

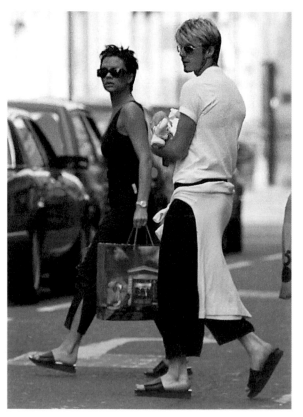

right
30th April, 1999
We managed to photograph Victoria and David leaving the Daisy and Tom store carrying Brooklyn who was now eight weeks old. Already he was wearing DKNY shoes and a Tommy Hilfiger top. It was around this time that stories began to appear in the press about Victoria losing weight.

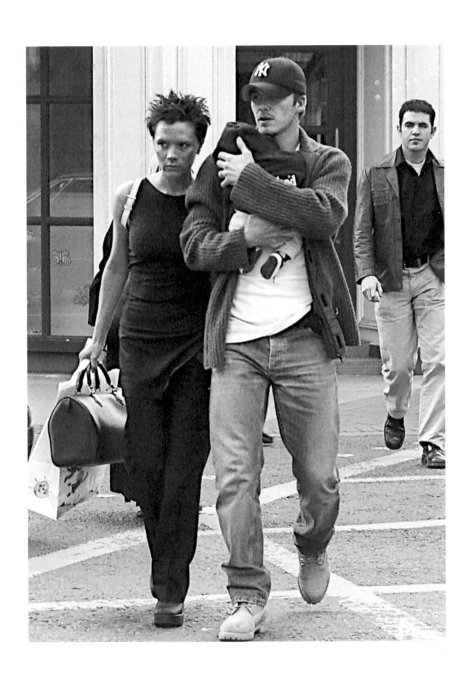

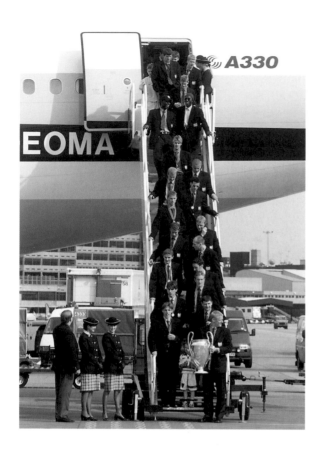

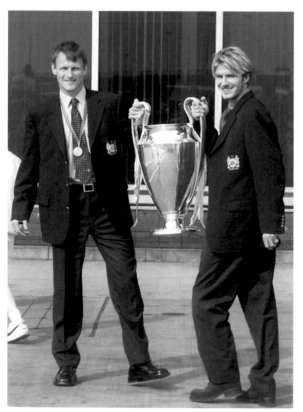

27th May, 1999
Manchester United had won the European Cup –
and with it the Treble. We were allowed on to the
tarmac at Manchester Airport to take pictures,
and we took some as they were coming down
the steps off the plane. Once on the ground
Beckham chose Teddy Sheringham to hold the
cup with him.

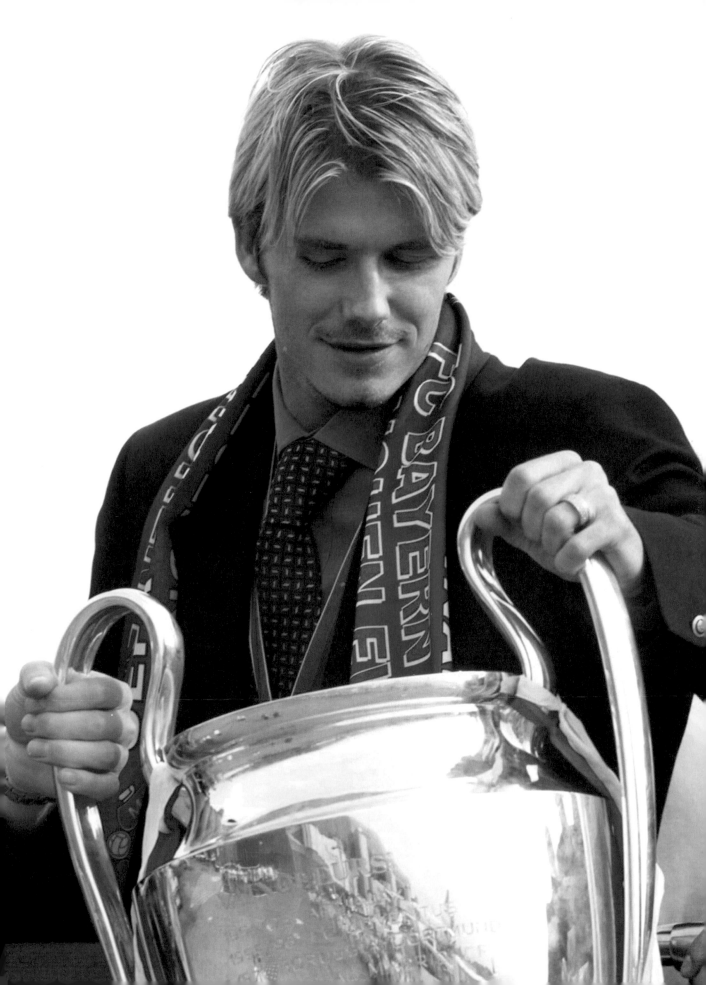

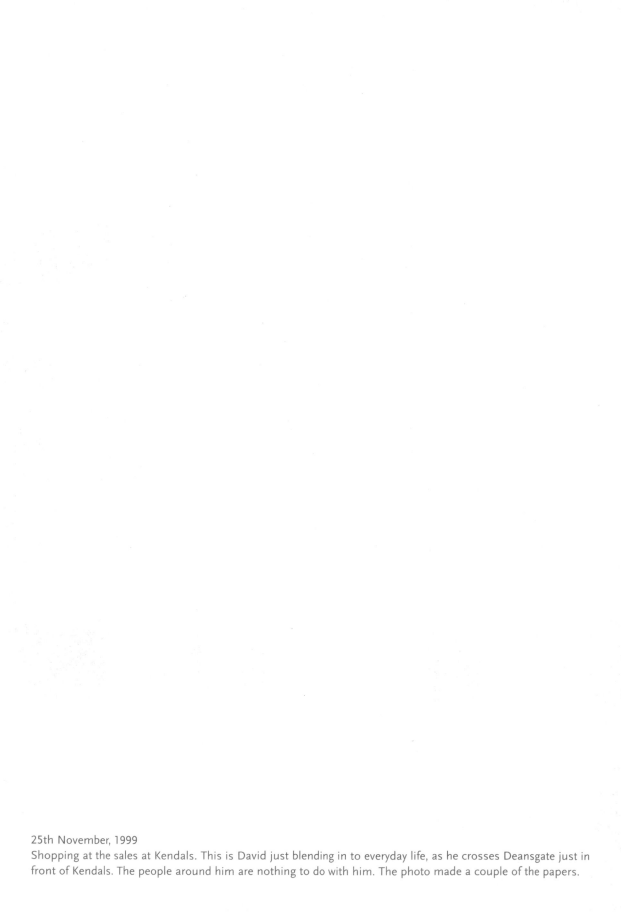

25th November, 1999
Shopping at the sales at Kendals. This is David just blending in to everyday life, as he crosses Deansgate just in front of Kendals. The people around him are nothing to do with him. The photo made a couple of the papers.

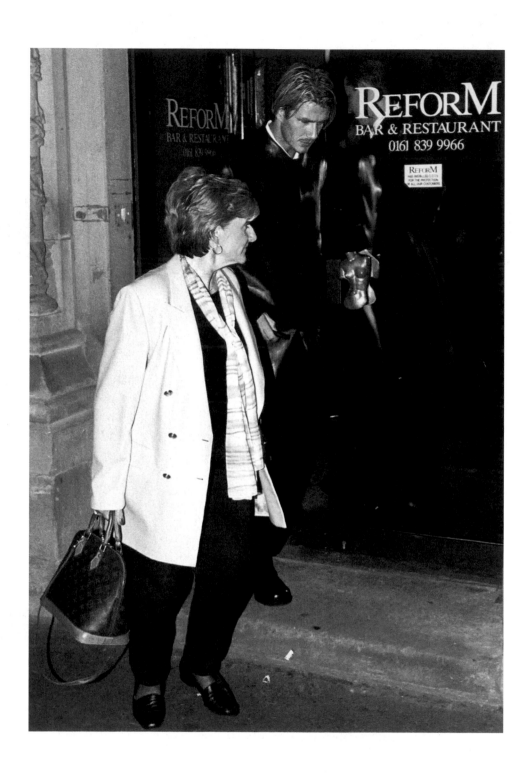

11th October, 1999. Outside the Reform restaurant, Manchester.
After a dinner in honour of Sir Alex Ferguson following a Testimonial match at Old Trafford
earlier in the evening. Leaving with his mum.

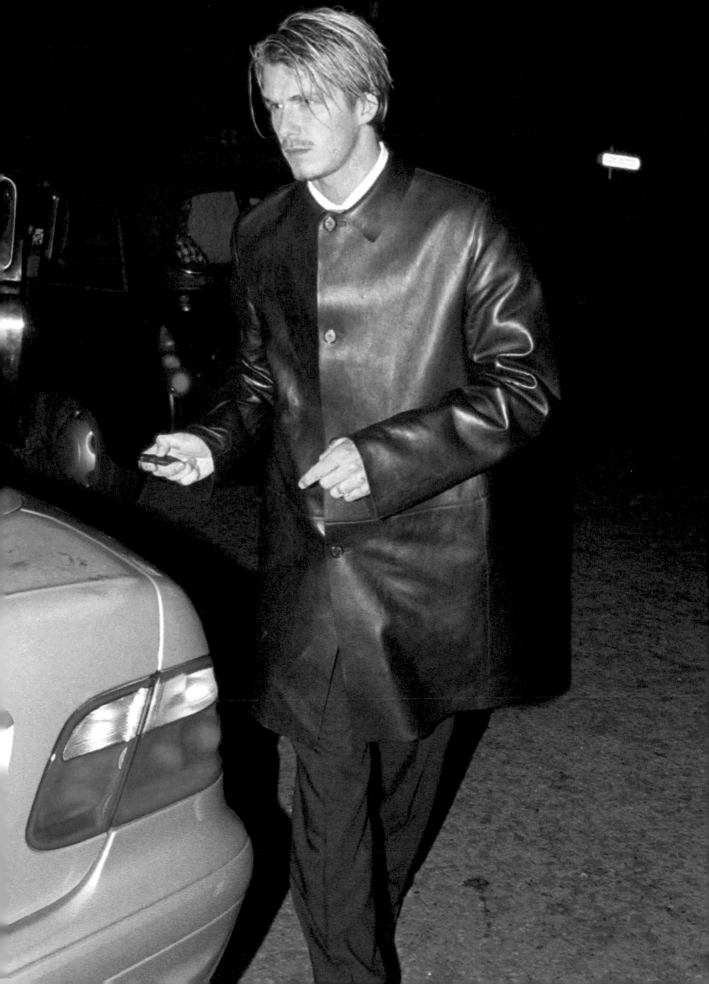

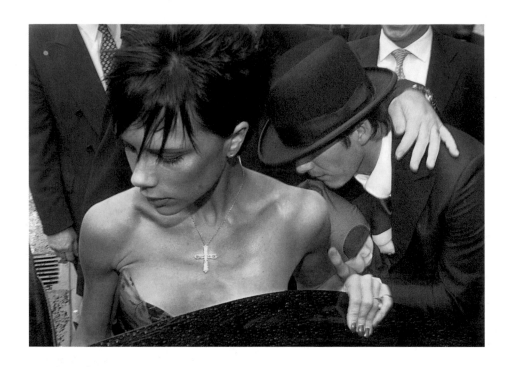

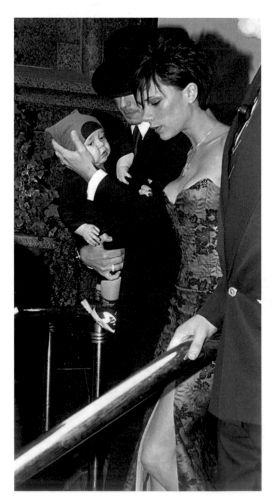

30th December, 1999

These photographs were taken at the wedding of Phil Neville and Julie Killelea, an ex-girlfriend of David Beckham. There was a large press pack outside. 'Posh and Becks' were accused of stealing the show by some of the media even though they didn't pose for the press. The press also commented that some of the wedding photos included not just the bride and groom, but also 'Posh and Becks'. They also got a little over-excited that David didn't take his hat off in church. The photo on the right, of David and Brooklyn, got widely used.

Next day it was business as usual for the United players as Sir Alex made them go training as this was right in the middle of a very hectic period of football fixtures.

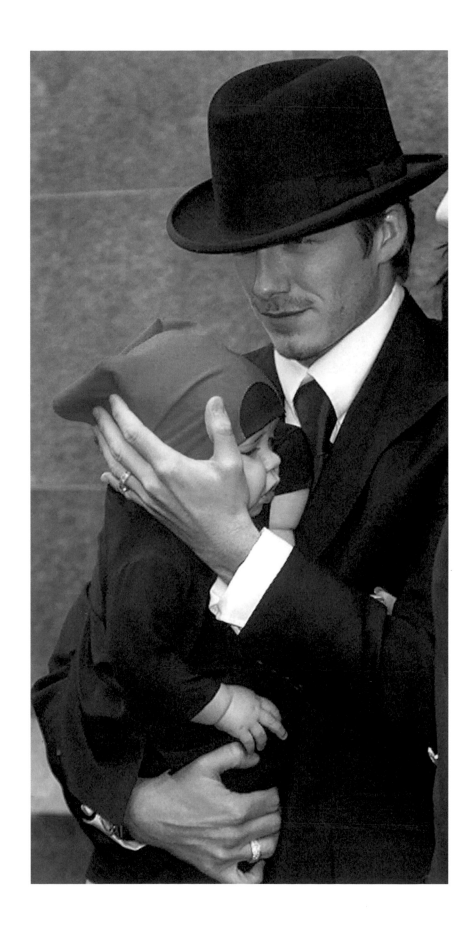

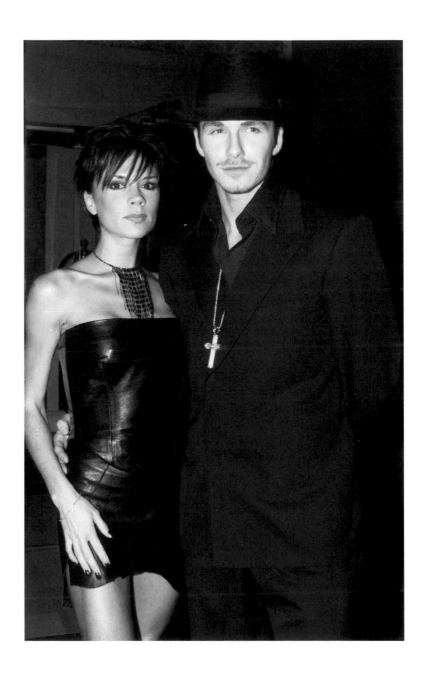

31st December, 1999.
Millennium night, leaving the Midland Hotel. We knew they were there, but the rumour was that they wouldn't
pose, and that they'd leave via the rear exit, so the pack of photographers left to go to celebrations at Castlefield.
We decided to wait, and James and I were the only photographers left. His driver came out and said that he wanted
to see who we were. He said that David wouldn't stop, but he would let us do pictures. They were used everywhere
in the Sundays on New Year's Day – *News of the World*, *Sunday Mirror* – and lots of magazines bought them.

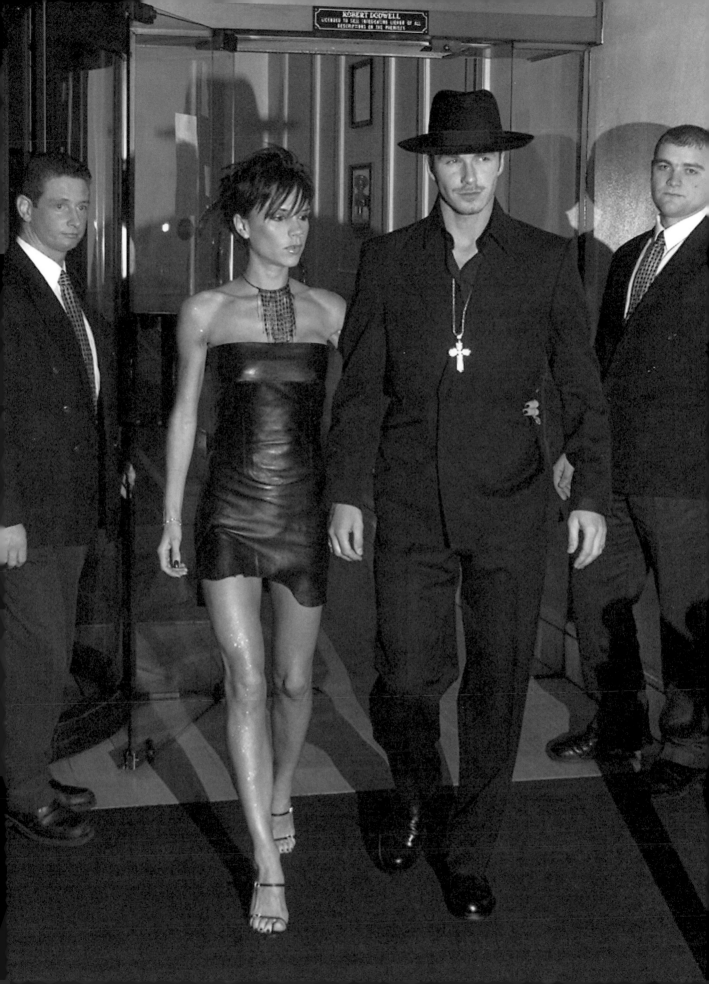

4th March, 2000. The evening of Brooklyn's first birthday.
David took Victoria to the Reform for dinner, leaving Brooklyn at home. He wasn't keen on being photographed, and was very protective of Victoria.

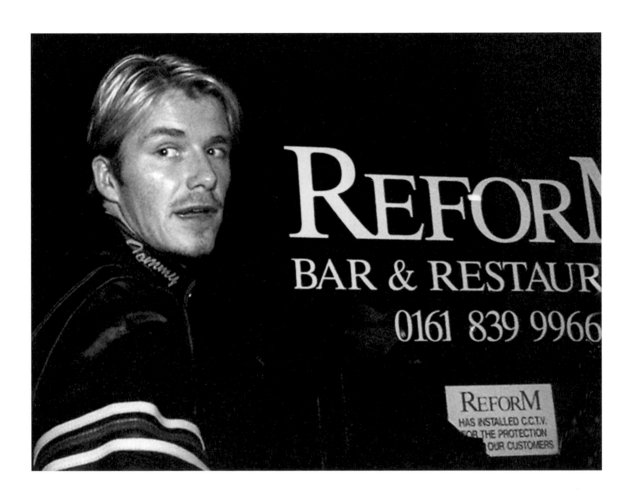

March 5th, 2000. Brooklyn's first birthday party.
This was taken at Cottons Hotel, not far from Mere Golf Club, on the way to Knutsford. They had hired clowns for the event and there were lots of members of the public there. Mark Niblett, their minder and driver, was with them (to the right, behind David Beckham in this photograph). He was later to publish a 'kiss and tell' book.

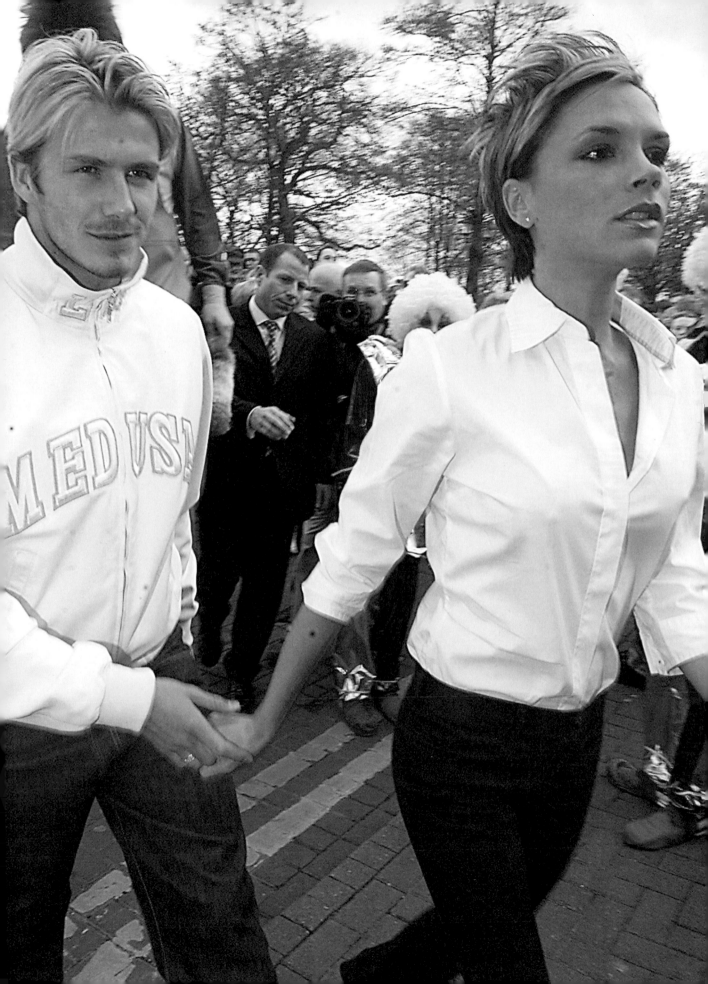

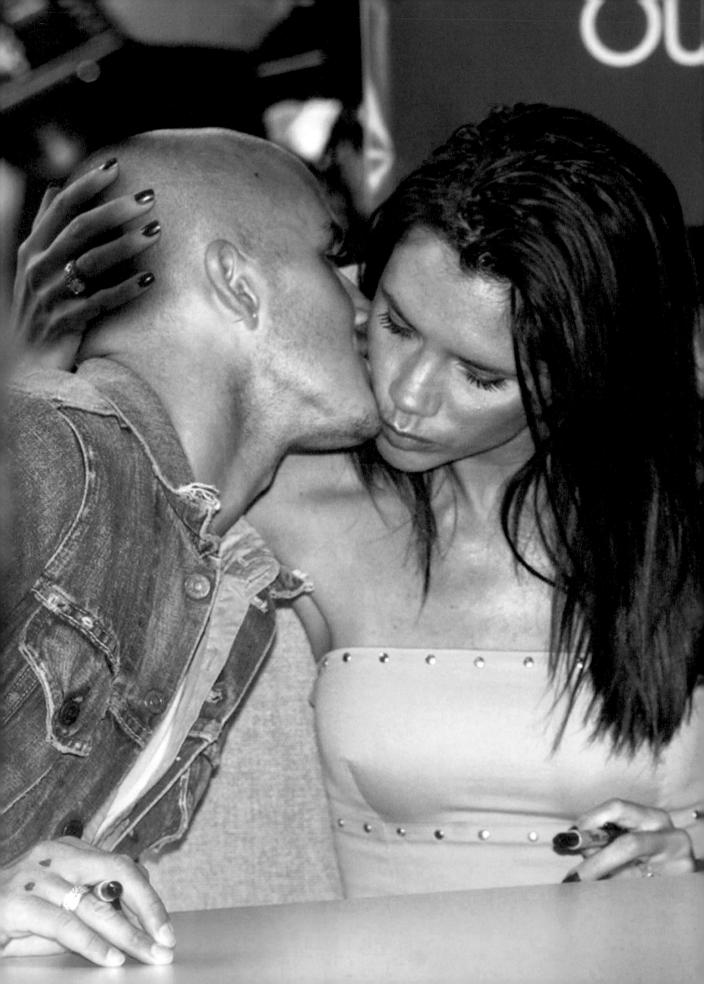

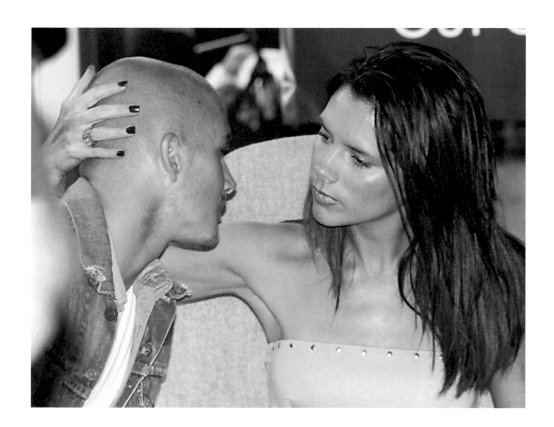

15th August, 2000. Woolworths, Oldham.
This was at a record signing at Woolworths with Dane Bowers and Victoria, for the single 'Out of your Mind'. David turned up to give support and sign autographs. The picture on the left appeared on the front page of *The Sun* under the headline 'Desperate', saying how desperate 'Posh' was to be using her husband to sell records. We never get to provide the final captions they use in the papers and so it's often a big surprise to us to see how a story has been slanted.

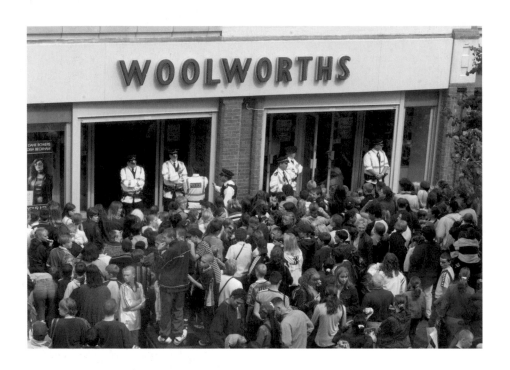

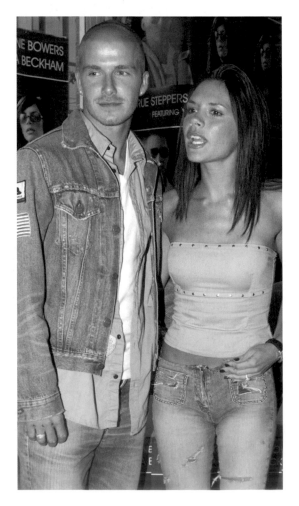

above
15th August, 2000.
Crowds gathering outside Woolworths in Oldham, before Victoria Beckham's record signing.

left
With Victoria at the signing.

below
Signing autographs. The marks on his knuckles were apparently the result of doing some boxing training.

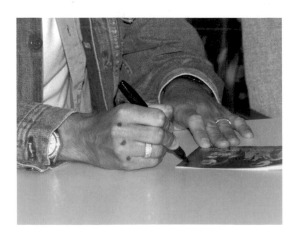

4th October, 2000
At the launch of the
Manchester United film.
Unfortunately the film
followed the team during a
season in which they won
nothing, after they bowed
out of the FA Cup to travel
to a competition in South
America. The film launch
was in aid of UNICEF.

19th October, 2000. Book Launch at WH Smith, Trafford Centre.
The crowd was enormous. He was in there for hours – probably three or four – and
to make things worse for him, he had a cold or flu. He signed literally thousands of
autographs. The fact that he wore a Pringle jumper was reputed to have helped to
revive Pringle's fortunes.

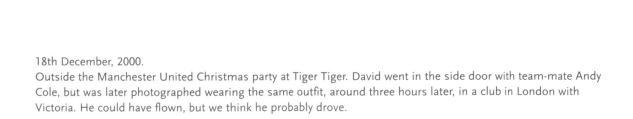

18th December, 2000.
Outside the Manchester United Christmas party at Tiger Tiger. David went in the side door with team-mate Andy Cole, but was later photographed wearing the same outfit, around three hours later, in a club in London with Victoria. He could have flown, but we think he probably drove.

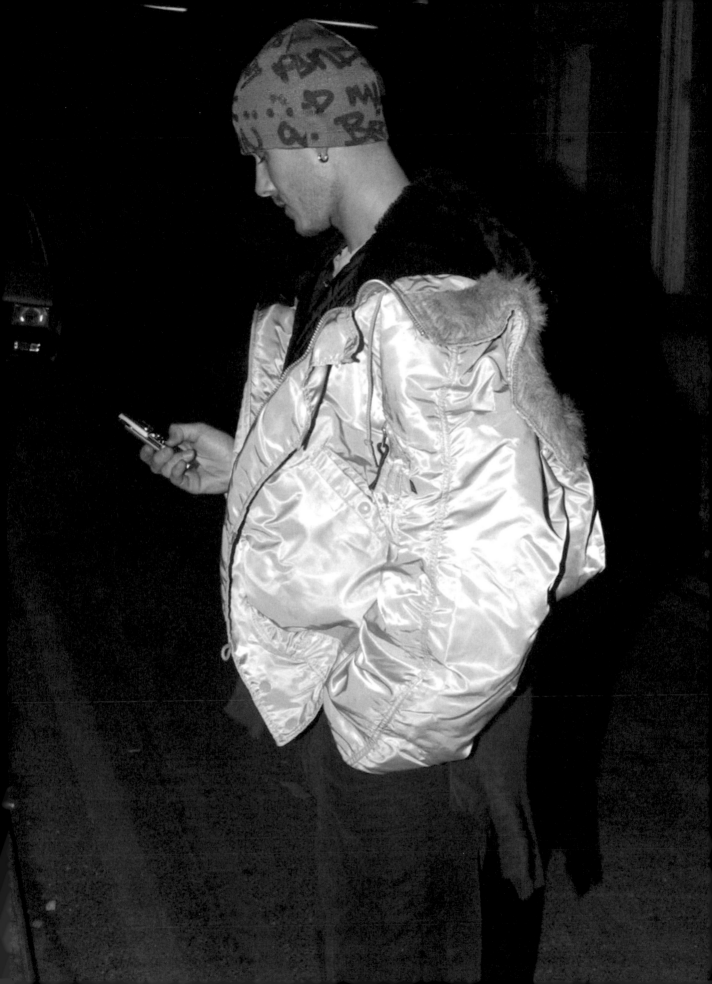

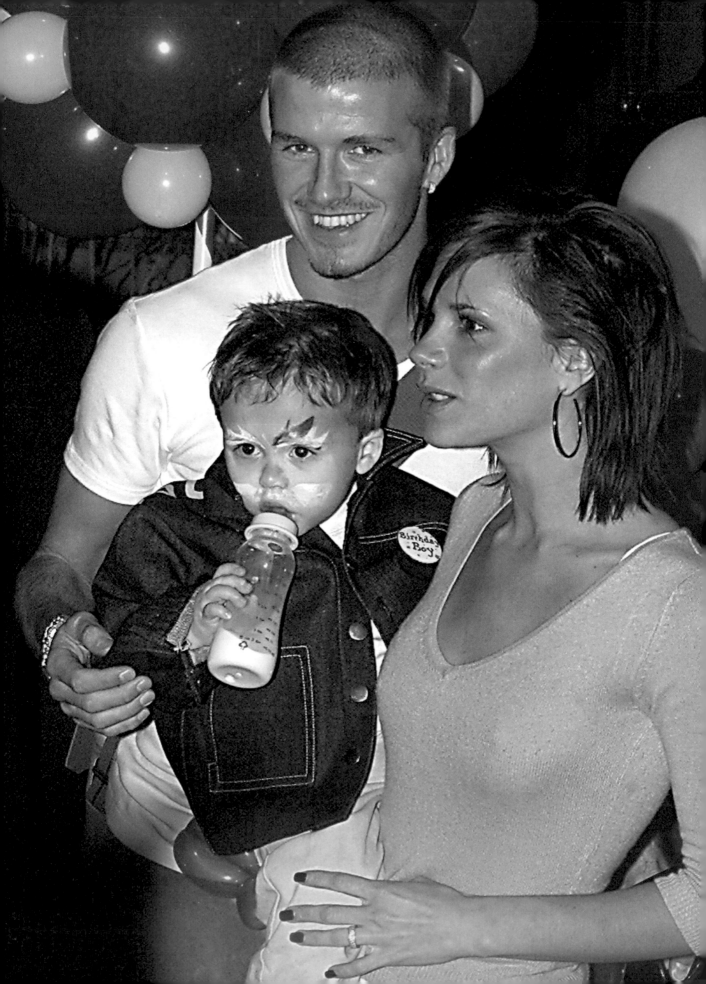

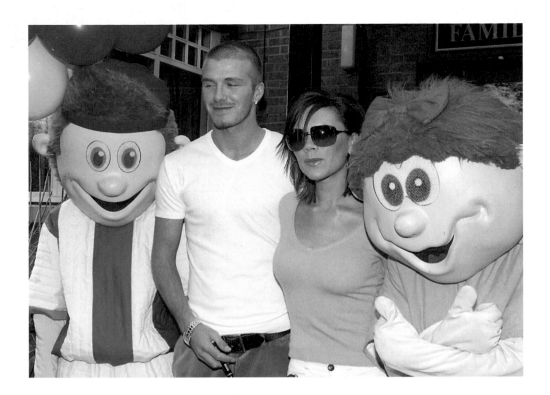

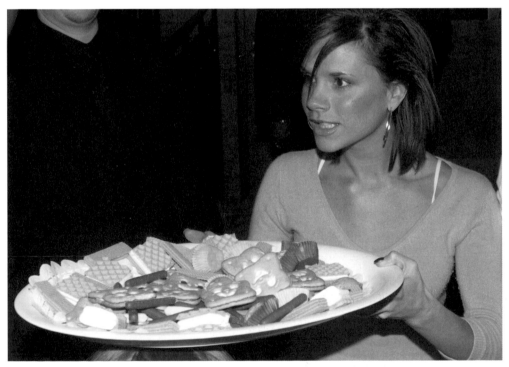

4th March, 2001. Brooklyn's Second Birthday. At the Wacky Warehouse in Alderley Edge.
With a birthday in March, it was always freezing cold. Victoria came out and was very nice to us.
Brooklyn had his face painted as a tiger. David posed with Brooklyn, which on his first birthday,
he didn't. Brooklyn was wearing the same jacket as his dad, and had spikey hair.

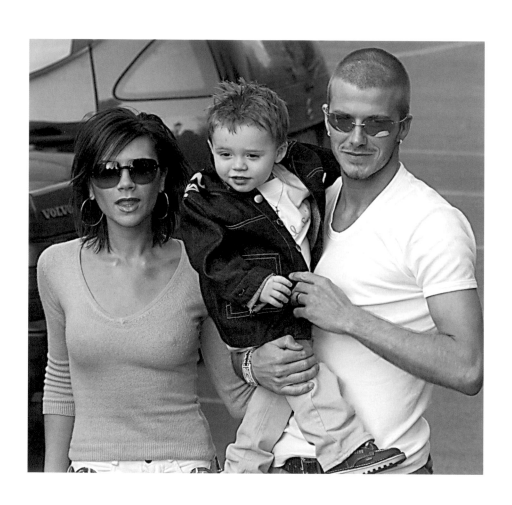

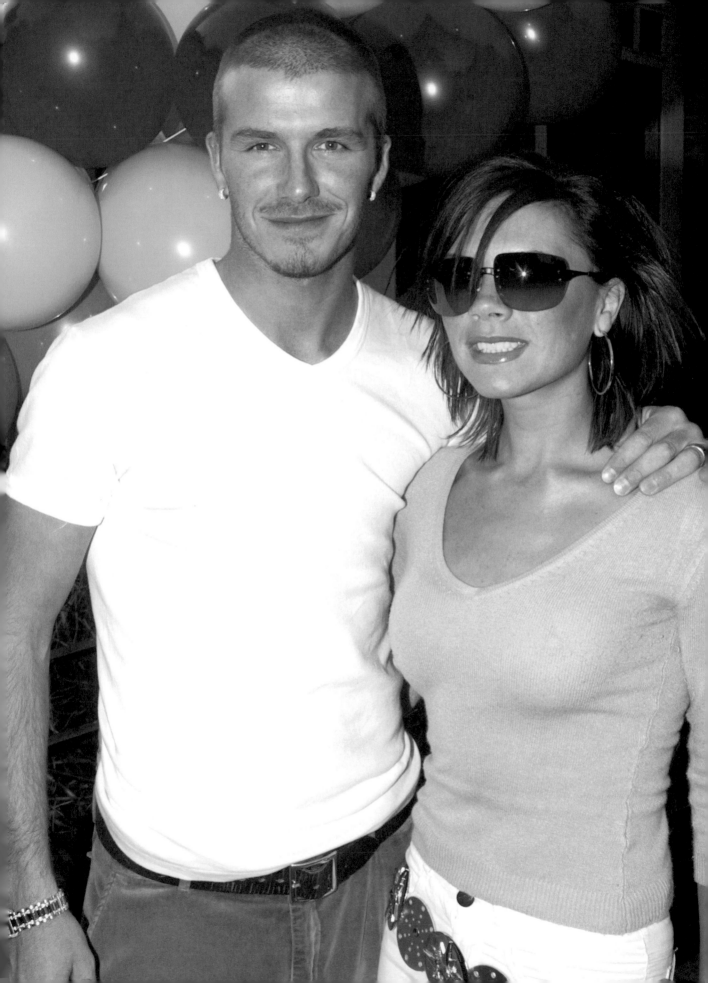

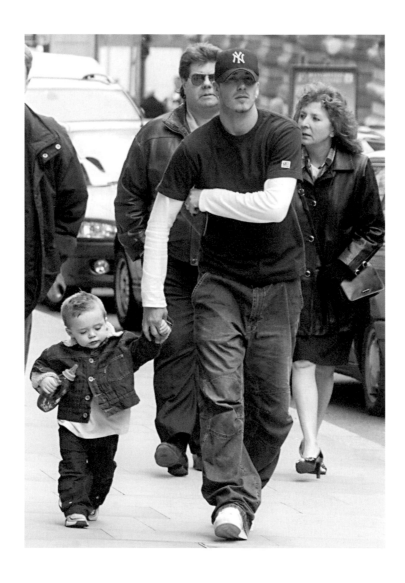

above
12th April, 2001. Shopping with Brooklyn

right hand page – top row and middle left
29th March, 2001. Walking around Manchester whilst chatting on his mobile phone. He had arrived back in Manchester in the early hours after having been away on World Cup duty.

right hand page – bottom row and middle right
16th August, 2001. Taking a coffee break whilst shopping on King Street, Manchester.

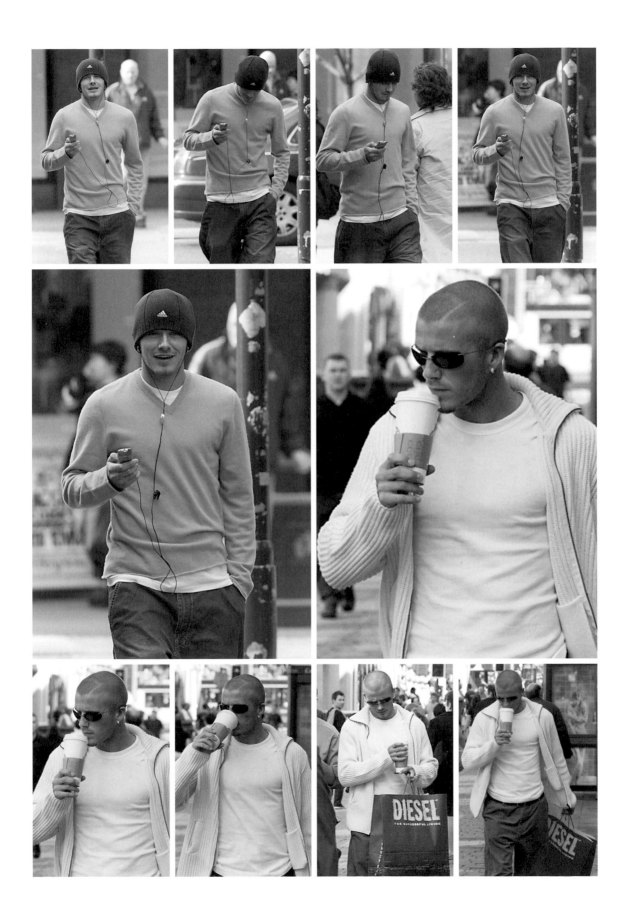

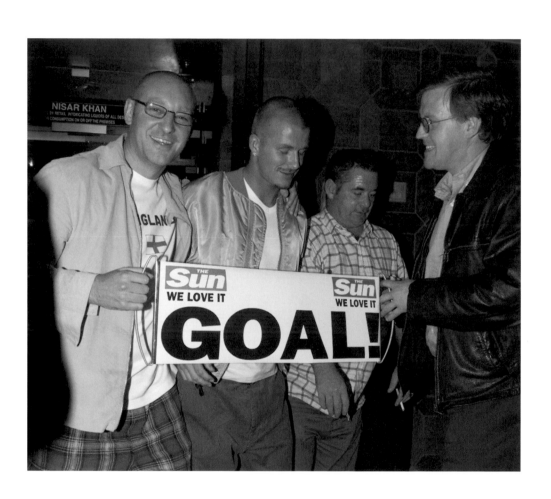

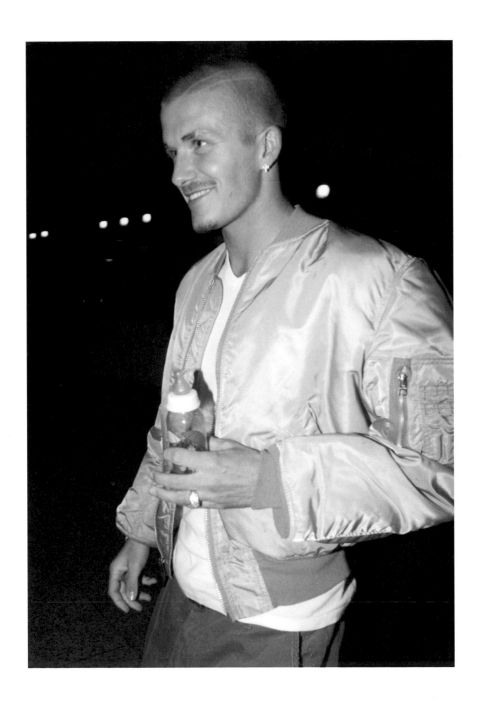

6th October, 2001
Just after he scored a goal against Greece, to equalise 2–2 and take England into
the World Cup finals. He was a hero. To celebrate he took his family to Shimla
Pink's Indian restaurant. The family left via the back exit, but then he agreed to walk
out of the front, where he was greeted by two *Sun* journalists with a 'Goal' banner. I
think he knew what was going to happen, but he did look embarassed by it all.

12th December, 2001. Old Trafford.
Before the match against Derby County. The photograph made the back page of *The Mirror*. James was just in the crowd. David signed everything, one of the few players that did. Many of them only do five or ten. He started at one end of the line of autograph hunters – all the fans – and worked his way right down. Fans would get there hours before with their programmes, books and things. Some players will sign everything, some players just ignore it all. David must sign more than a couple of hundred each day. He never looks up, just gets his pen out and signs away. But he's always guarded, all the way down. There was no attempt to stop us. If you blend in you are one of the fans and there are so many flash lights going off.

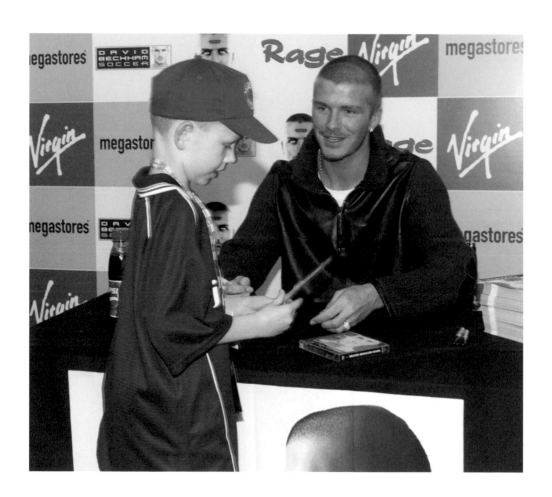

22nd November, 2001. Virgin Megastore.
The launch of the computer game *David Beckham Soccer* at the Virgin Megastore on Market
Street. It was a PlayStation game. He was happy to sign autographs, and to pose with the game.
He did either four or five stores that day – an exhausting schedule.

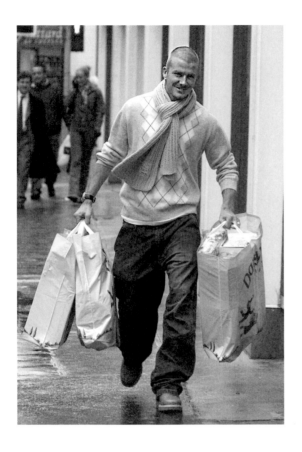

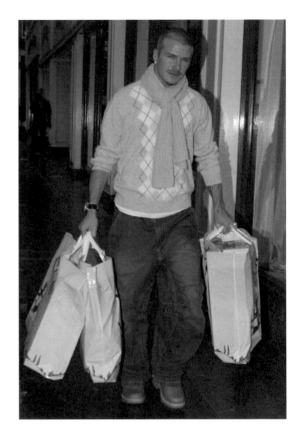

21st December, 2001.
After shopping at Daisy & Tom, David saw us and let us take these pictures – he seemed quite keen. Pringle jumper, scarf. James used a short lens with a flash, and I used a long lens without a flash – trying to cover all the options – the flash one looks like night-time and the long lens looks a little grainy. The photos were widely used.

19th January, 2002.
Arriving by taxi for the Ryan Giggs Testimonial Dinner at the Midland Hotel.

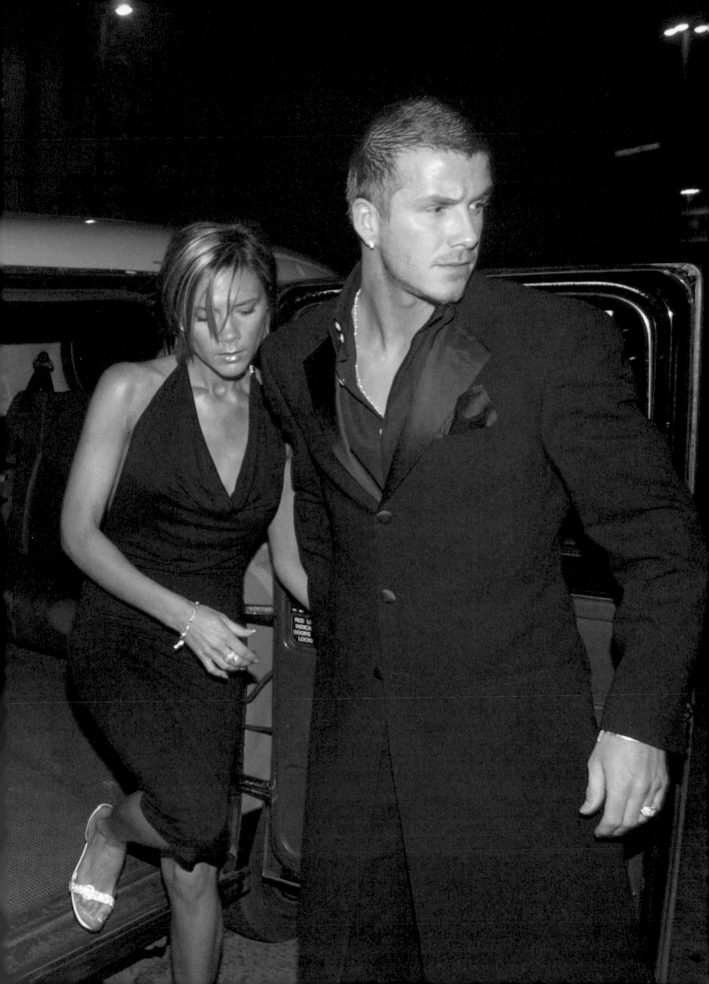

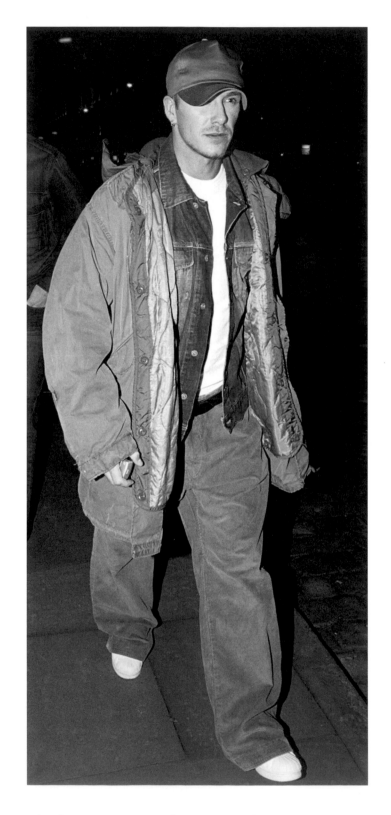

6th February, 2002. Leaving the Printworks after a private viewing
for Manchester United of the film *Bend It Like Beckham*.

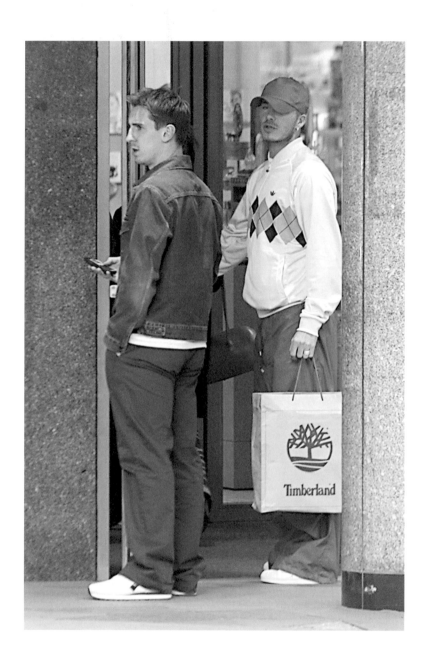

15th March, 2002. Outside Kendals. David Beckham and Gary Neville hiding in the doorway of Kendals from a female photographer working for a Manchester agency. It seems that she was beginning to annoy them.

following page
26th August, 2002. Filling up his Ferrari 360 Spider at his local petrol station in Alderley Edge. The number plate includes the number 7 and by this point there were lots of news stories saying that he was obsessed by the number 7. It was said that when he shopped at Marks & Spencer in nearby Handforth Dean he would only use aisle number 7 and that on occasion the store would open it up specially for him.

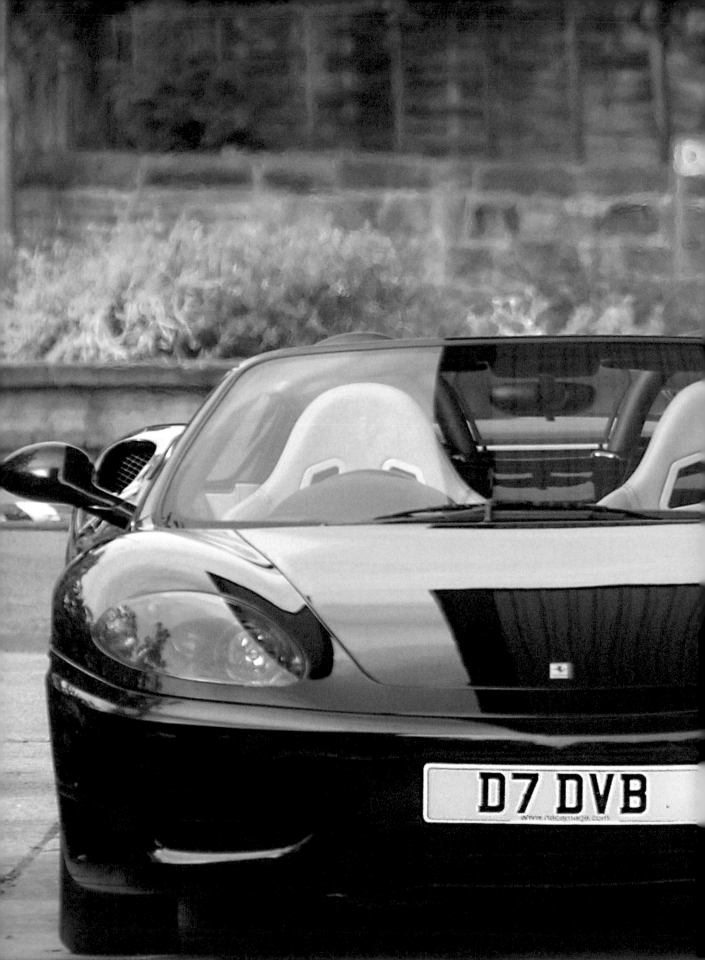

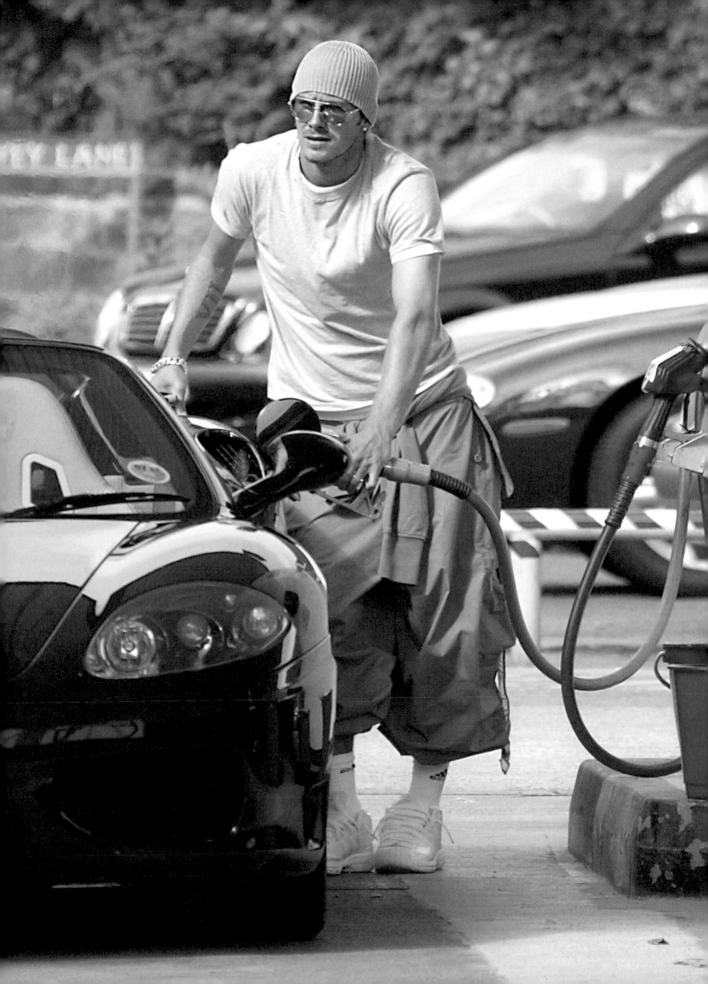

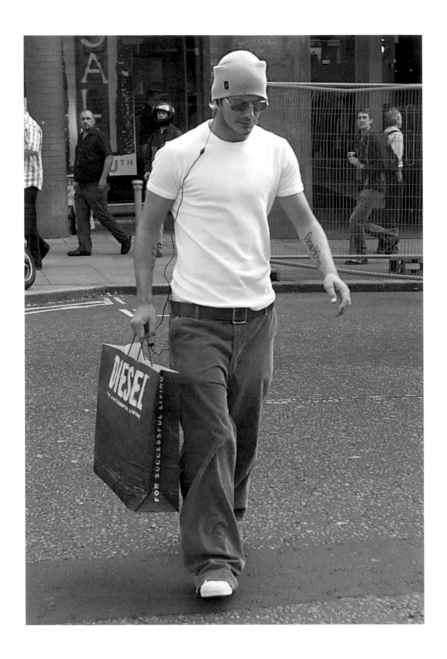

12th September, 2002. On King Street. He had been to Diesel and Flannels. He said that we could take photos by his new car. We asked which car? He told us that we'd find it on King Street, so we went up there and found the Bentley (*see following double-page spread*). There had been rumours about the new car for months but this was the first photograph of him with it. Every paper used it. Once again, we never saw him say no to people asking for autographs, and he even let people take pictures of themselves next to the car.

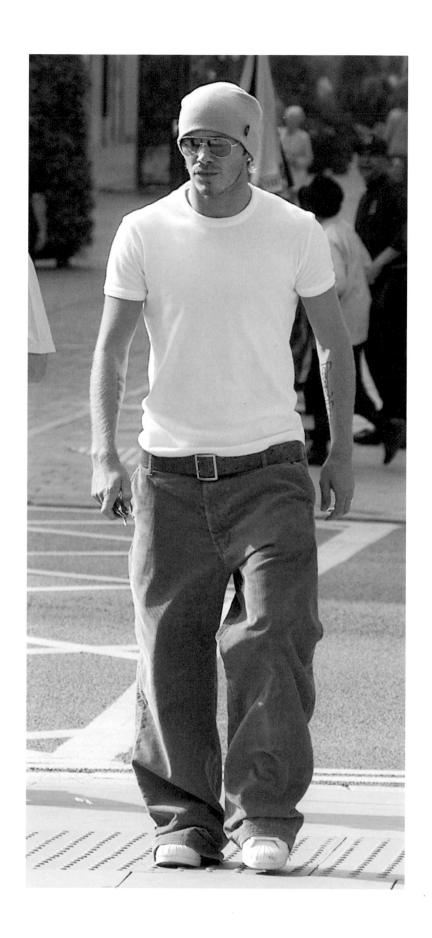

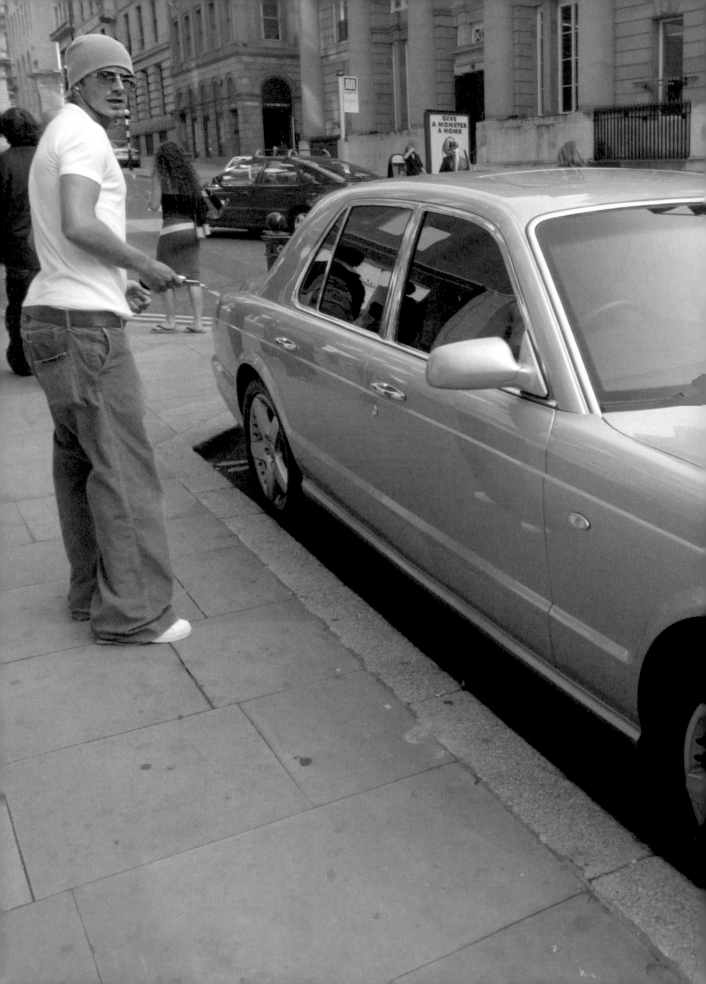

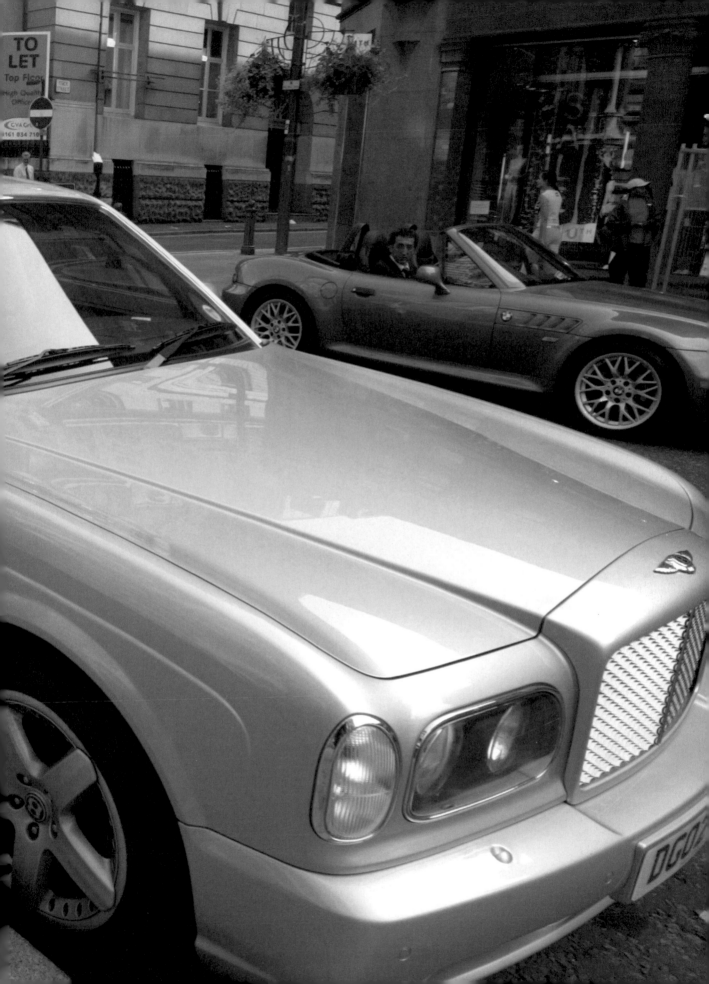

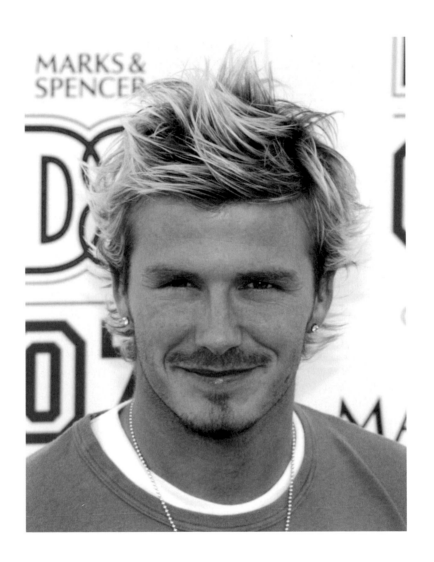

19th September, 2002
Launch of DB07 kid's clothing range for Marks & Spencer, which was held at the Urbis Centre in Manchester.

left
25th September, 2002.
These are the first pictures ever of Romeo Beckham. It was a pure fluke. We were walking through St Ann's Square and happened to look up at the newly built No.1 Deansgate, where we knew Gary and Phil Neville lived. We weren't expecting it at all – we didn't have long enough lenses, and we could have done with a different angle. But it was one of those things; we really needed to go back to the car and get the equipment but you can't – you have to take the shot and hope there's something on it. We only had about 30 seconds to shoot and we couldn't really tell that there was a baby there until we got back and looked on the computer. And there it was – a picture of David nursing Romeo Beckham.

The photographs were used on the front page of the *Sunday People*, and by *OK!* magazine. To this day people can't work out where we took them from, it's such an acute angle – they were eight floors up – but there is David Beckham holding Romeo.

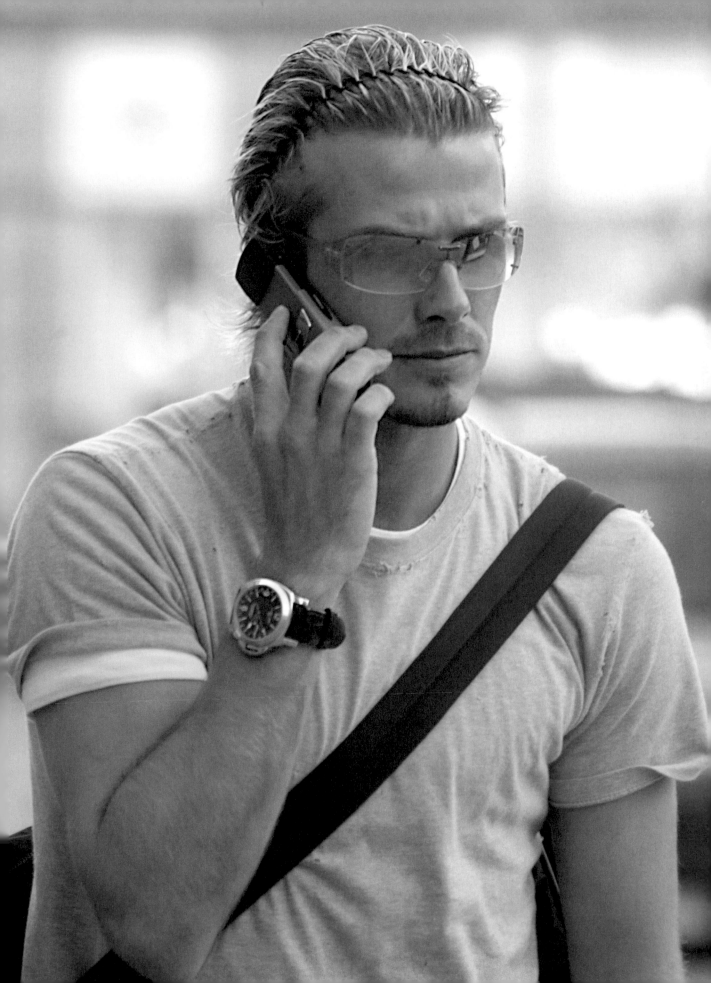

25th September, 2002
Out shopping again in the city centre. Sandals, ripped jeans, Diesel jumper. He had driven into Manchester in his Ford F150 Harley Davidson pick up truck. It was a day when he signed literally hundreds and hundreds of autographs. He signed autographs for everyone who came up to him. This was the time of the shock horror of the Alice band. He knew all along that we were doing the pictures. He was fine, he said hello, when he walked past. He never hid. By this stage, by September, he wasn't hiding, unless it was an amazingly big news story, but we were still asking him. I'd said that we'd like to take a few pictures. He just smiled and said he was going back to his truck. He never actually said yes, he would just say that he was going shopping, or that his truck was parked up there, or I'm going back up here. In other words – you know where I'll be.

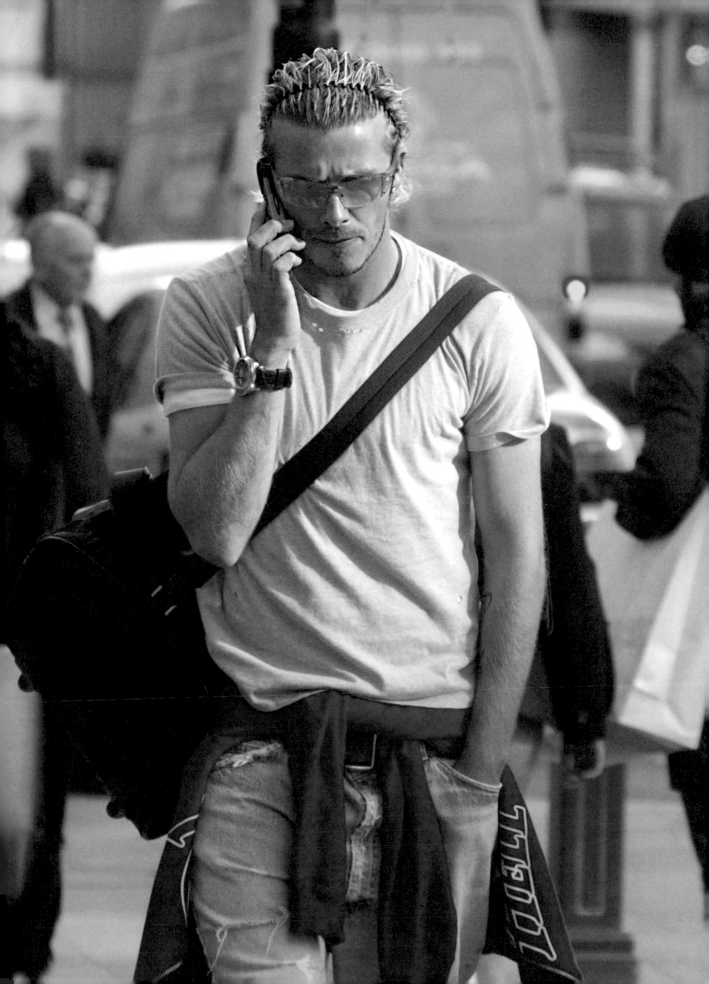

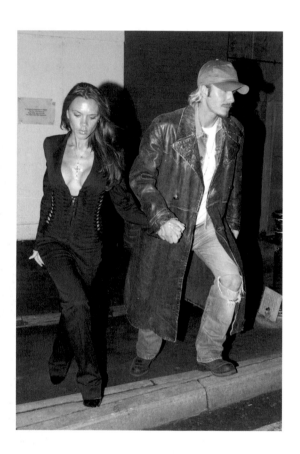 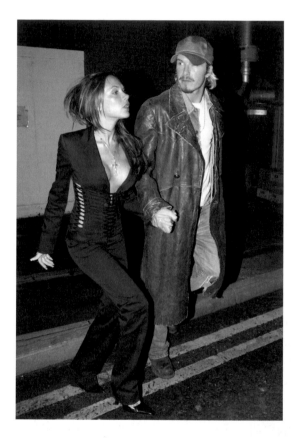

14th December, 2002

James took these pictures outside at the back of Sugar Lounge. This was the first time that David and Victoria were photographed together after the newspaper stories of the kidnap plot. Victoria hadn't been seen out in public with him. Beckham popped outside to see who we were, and James asked if it was okay. He said don't photograph us coming out of the back alley, but nearer to the van. The body guard was a little shocked that David had said it was okay to get a picture. Before this, they'd been in the Living Room and the bodyguard had been told that they were adamant that there should be no pictures. The minder stood back, which always makes it much easier to work. It always surprises me how relaxed they can look when they're being photographed, as if they have no idea that you're there. They were out with the actress Patsy Kensit that night.

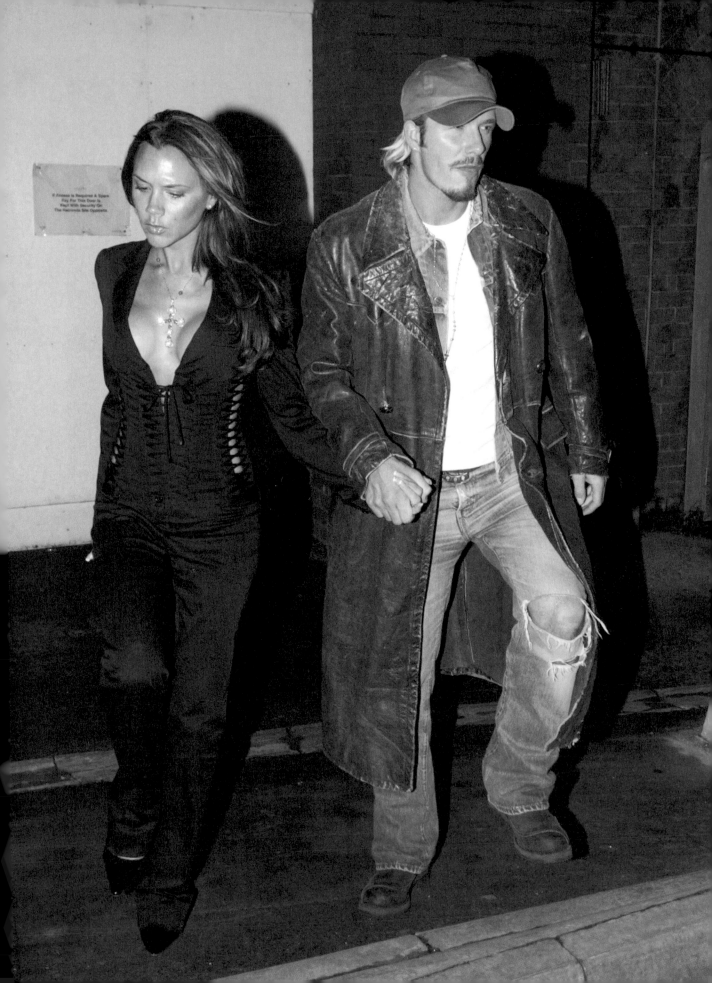

30th January, 2003
This was the launch of the Manchester United/Pepsi
sponsorship deal at the cinemas at the Printworks.
He was to appear with fellow United footballer Juan
Sebastian Veron. A saloon set had been built,
complete with cowboy-style swinging doors. There
were even rumours that Beckham and Veron would
be in costume. When he turned up he was looking
very dapper and had his Alice band on again. But the
set wasn't really used. There was a pack of some
twenty photographers – some of them blacked out
the Pepsi thing when their photos were used. But we
got some good head shots – the one on the right
was probably the most used.

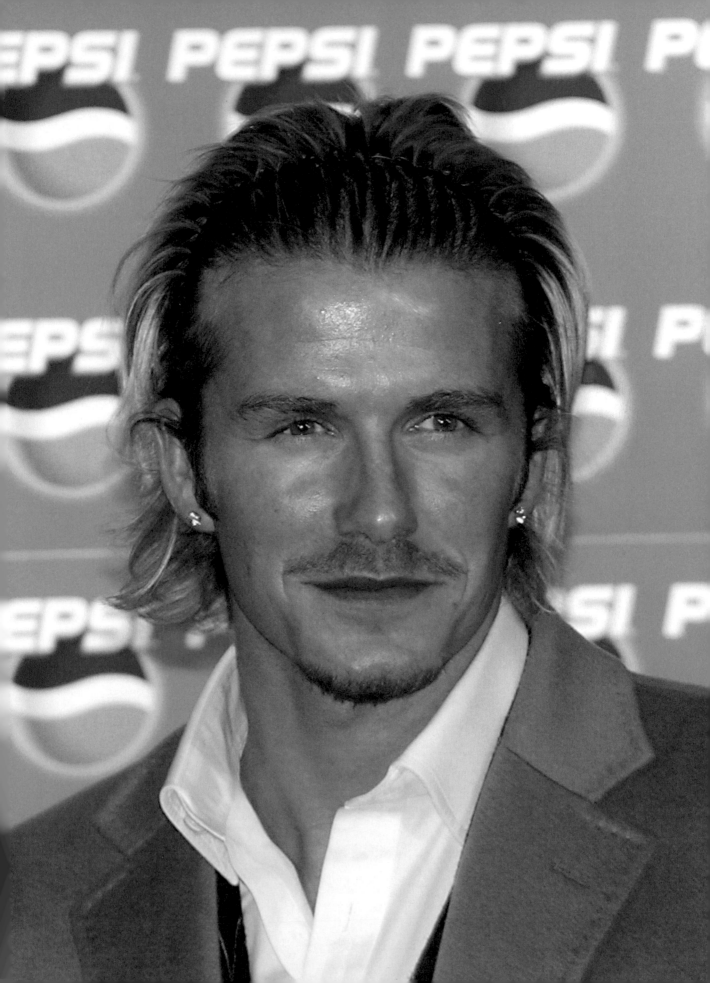

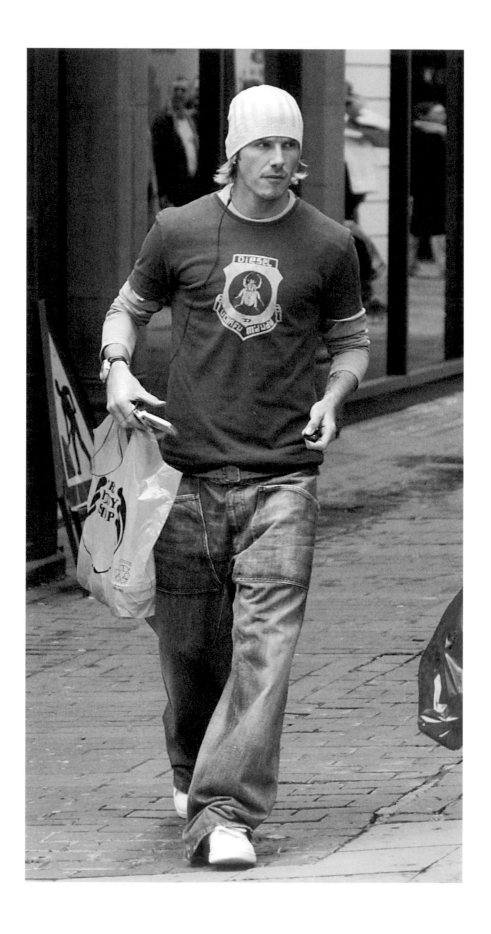

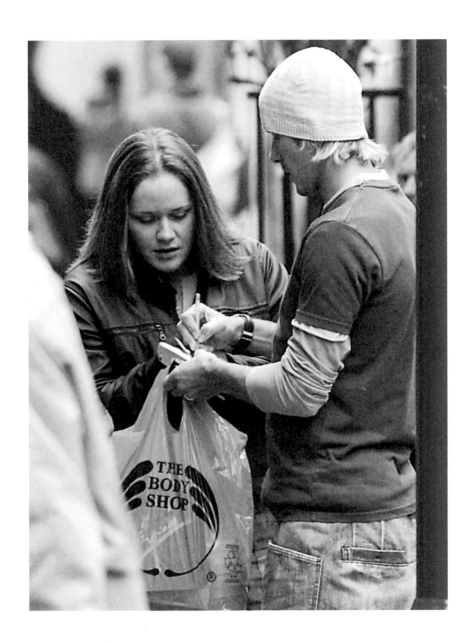

7th February, 2003
Out shopping in Manchester. He'd been to the Body Shop on King Street, and then he signed an autograph for some strange woman (actually James' girlfriend, Karen). She knew I was photographing him and had been watching me. Then, without my knowledge, she decided that she would go and get an autograph – go and meet David Beckham.

17th February, 2003

This was the Monday morning after the Sir Alex Ferguson boot-kicking incident that led to a cut above his eye. We knew this was a massive story, and it seemed as if the world and his wife was at Beckham's house. We never went there because we knew it pissed him off. And so we'd resigned ourselves to the fact we wouldn't be doing any Beckham pictures that day. We'd thought that there was no way he would be going out, and that he'd either be at the house or at the training ground. Instead we'd been out looking for anyone, soap stars, anything. In fact, I was at my accountants when James, who was on King Street patrolling, spotted David Beckham's truck. There was a story that another photographer had spotted it but decided it wasn't his. There was no tip off. There was a rumour that he'd phoned us, and there was even a piece in *The Mirror* recently saying this. But it wasn't true. David acted quite normally, he signed autographs and seemed to be quite happy to do so.

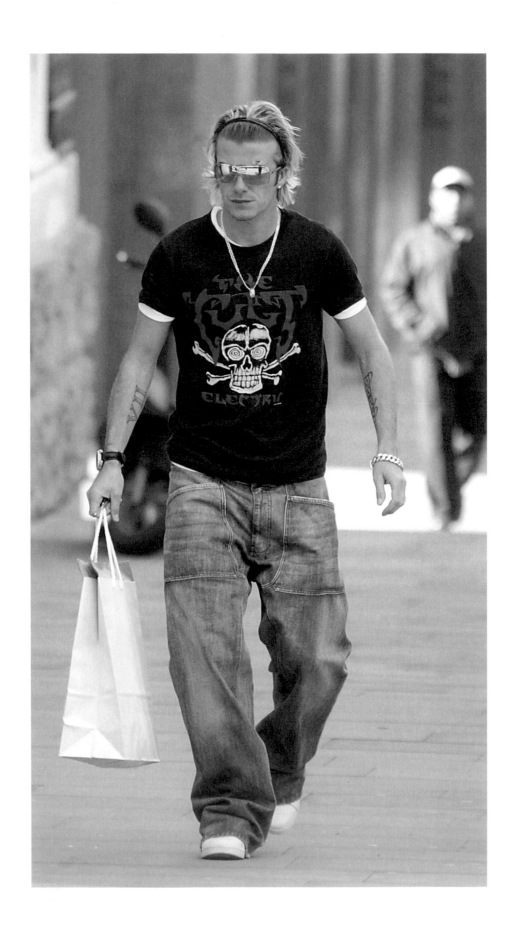

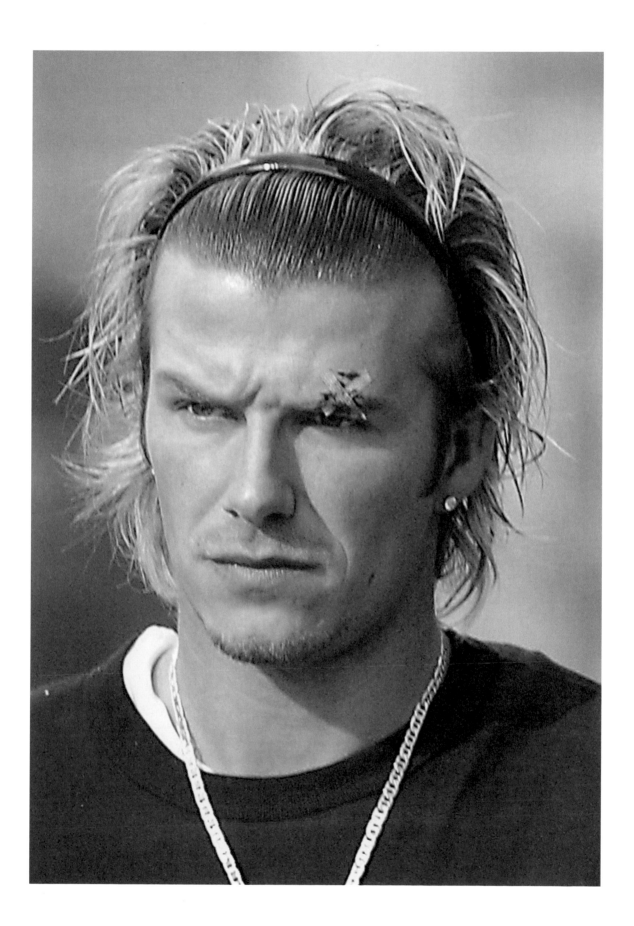

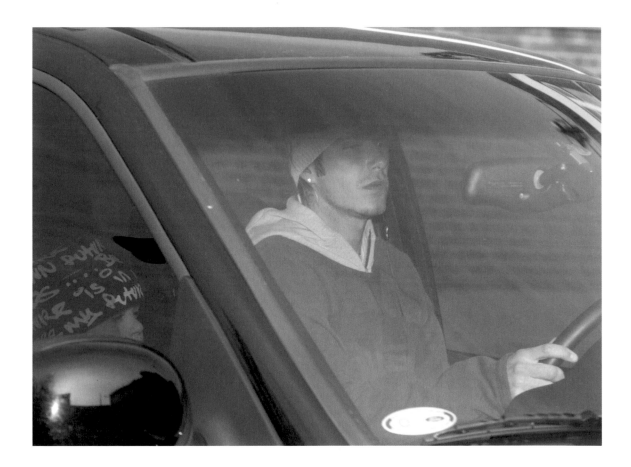

1st February, 2003

This is what we'd call a 'car snatch' really. He went to the Granada TV studios to film an advert and this is him arriving with Brooklyn in a designer hat and him in his red top. We heard that it was for an advert for the Japanese market. Victoria arrived minutes later in another car. Not the best car snatch in the world, really, but it is one of the most pressurised forms of photography. Car snatches are a nightmare. There's no second chance. There can be all sorts of problems – if the sun visors are down, or if the rear view mirror is so big that it either gets in the way, or casts a shadow. It's always luck – the luck of where you stand, the luck of the draw.

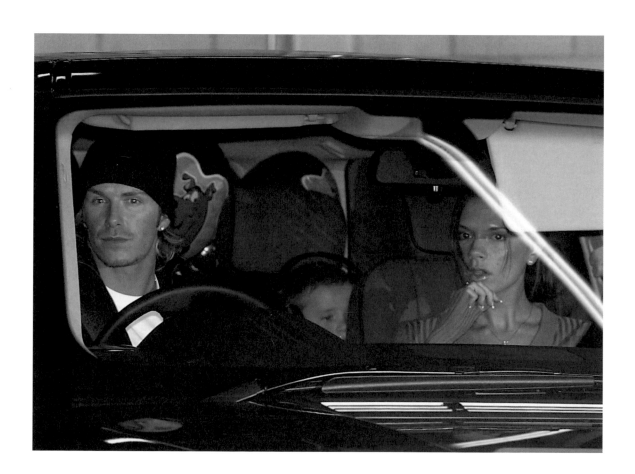

4th March, 2003. Brooklyn's birthday

Coming out of The Printworks, where the family had been to see *Scooby Doo*. There were better pictures on the day, but they weren't mine. London staff photographers tried to block the exit from the loading bay of the Printworks which the Beckhams would use, by putting a car across the road. For them it was a matter of block the road, get a picture, go back to London and never see them again. But we worked with them all the time – and he remembers the faces he sees day in day out. We had strong words with the London snappers and made them move their cars. As we said, 'Don't block the road just because you're not good enough to get the pictures'. What they were doing was stupid and potentially dangerous.

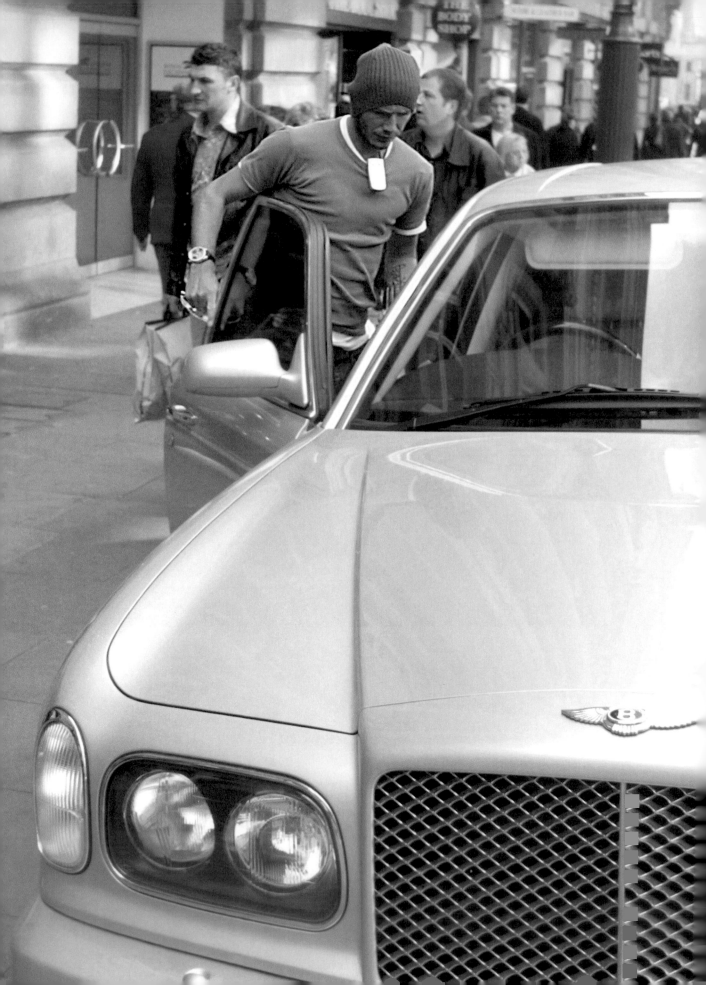

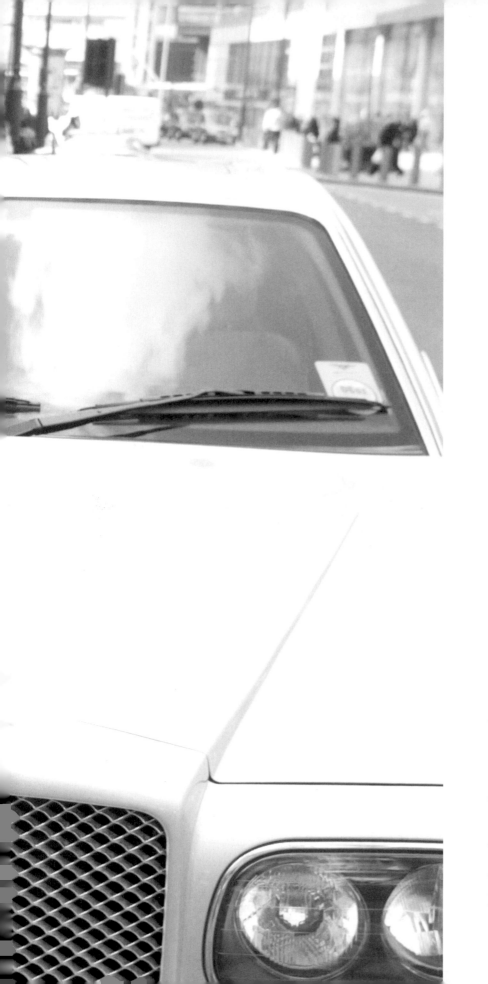

21st March, 2003
The biggest Bentley in
Manchester. David
Beckham went shopping
and no-one seemed to
notice him. It was as if he
was invisible – not one
person asked for his
autograph. As you'll see he
wears his mobile phone in
some unusual ways – the
very next day everyone else
also seemed to be wearing
their's around their neck.

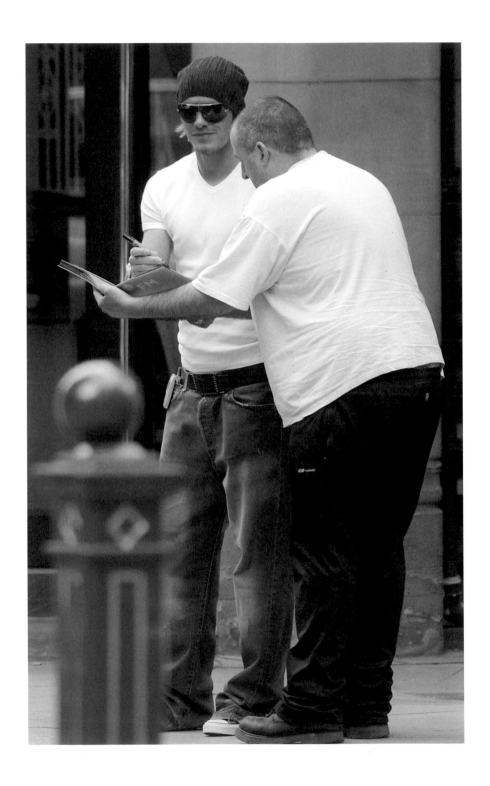

11th April, 2003
Signing autographs.

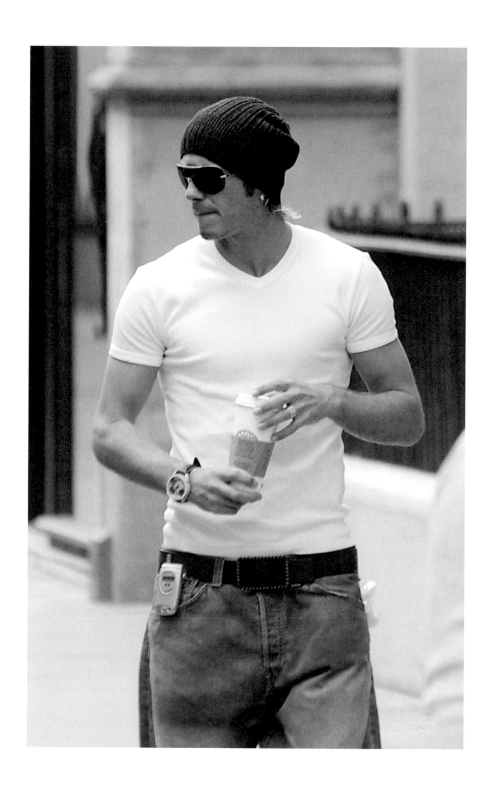

11th April, 2003. Shopping in Manchester.
We would regularly see him stopping to get a coffee from Starbucks.

11th April, 2003.
Out and about
in Manchester.

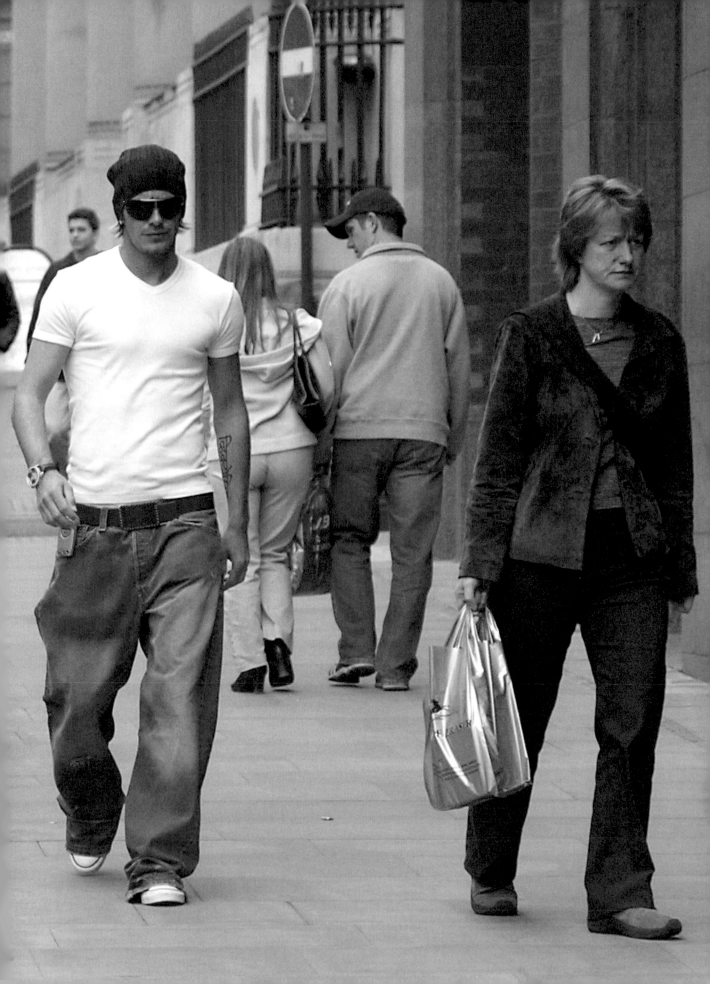

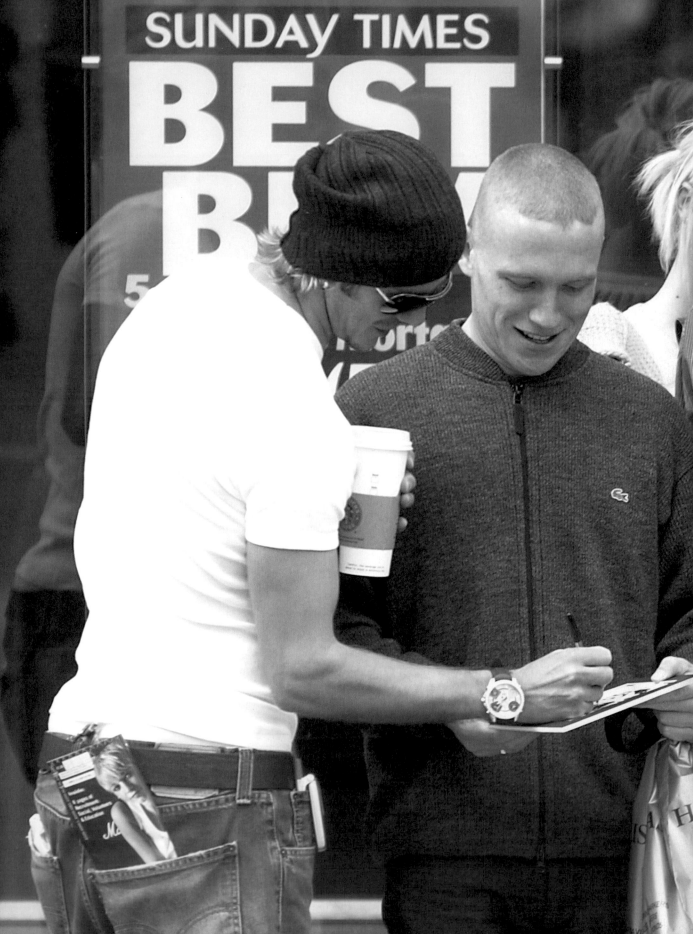

11th April, 2003.
Signing autographs.

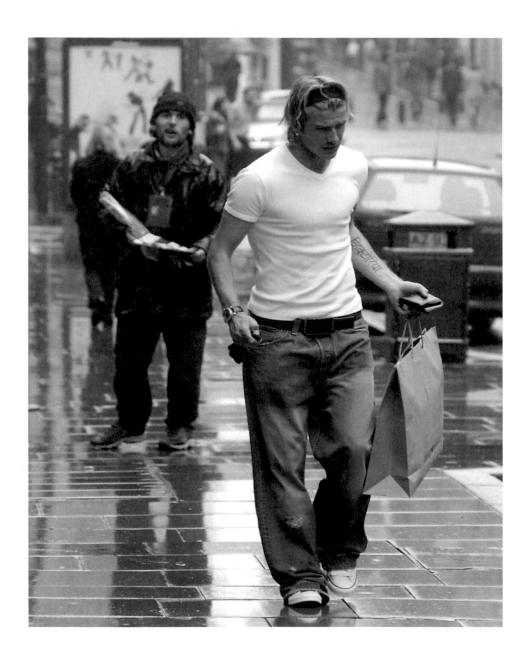

24th April, 2003
The day after Manchester United had crashed out of the Champions League. They had been beaten by Real Madrid. He'd been to Armani where he'd bought the black suit that he would wear when he went to the races with the other United players (*see later photo*). Armani also did the England team suits. It was absolutely pouring down – I had to use flash for these pictures. Manchester in the rain is so dark. He knew I was there and, again, didn't seem to bat an eyelid. He had the big, thick Alice band by now, white t-shirt, jeans.

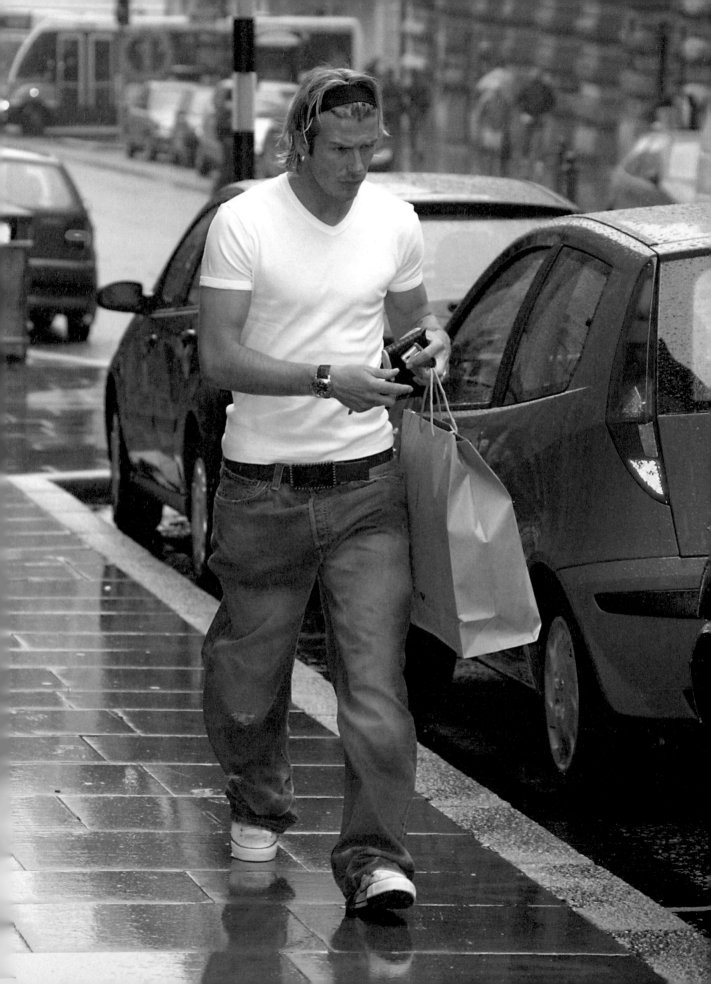

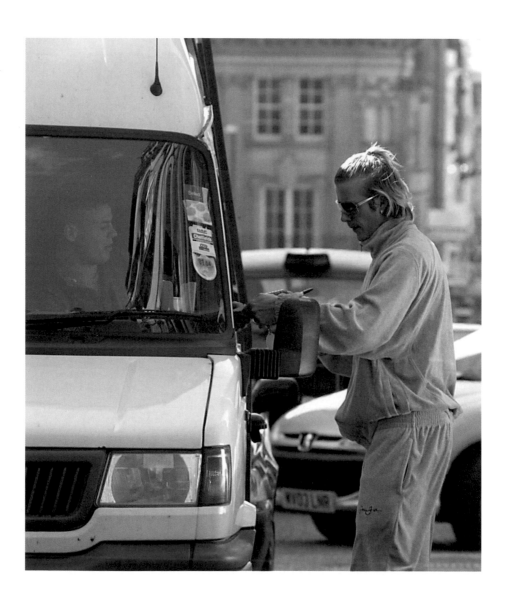

6th May, 2003
Out and about on the streets of Manchester. We were still waiting to see if United had
won the Championship – waiting for the Arsenal result. Beckham had been shopping at
Emporio Armani. He was wearing a grey tracksuit and had one trouser leg rolled up – we
never knew why – and as always he was signing autographs for everyone and anyone. By
now rumours were rife about him going to Real Madrid, but he still denied it. He was in
the Bentley that he still owns to this day.

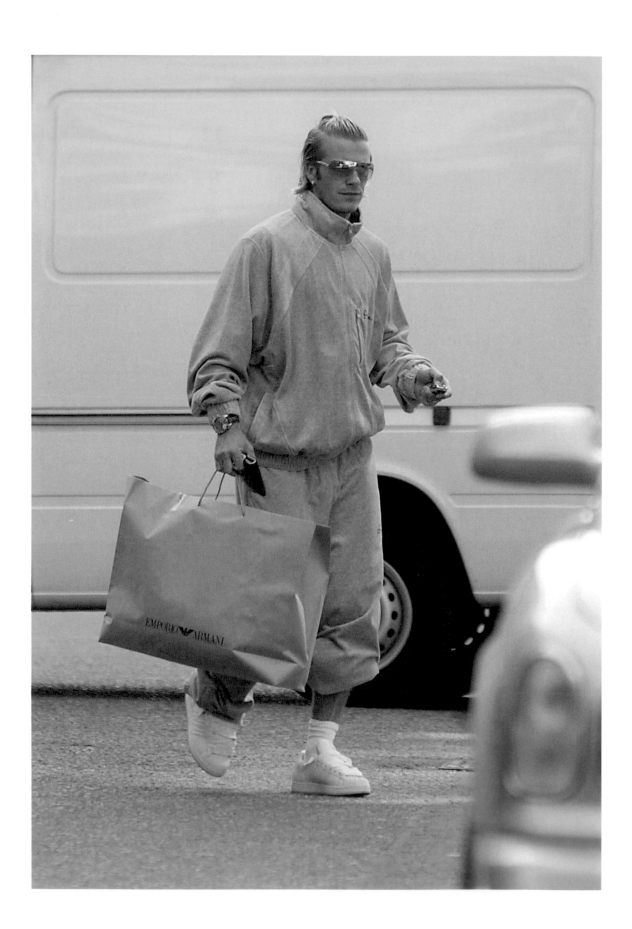

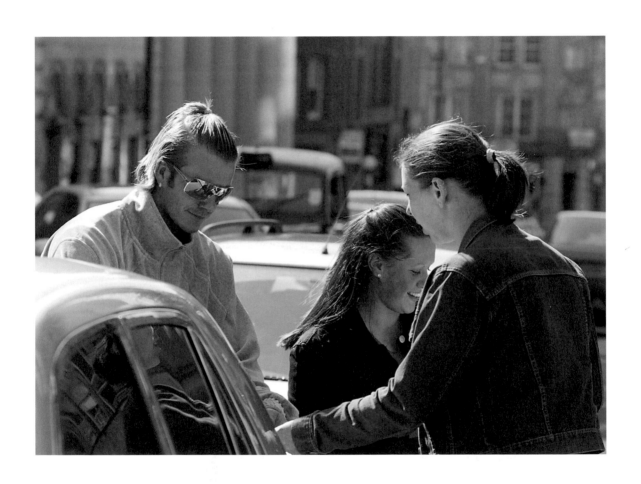

6th May, 2003
Signing autographs after shopping at Armani.

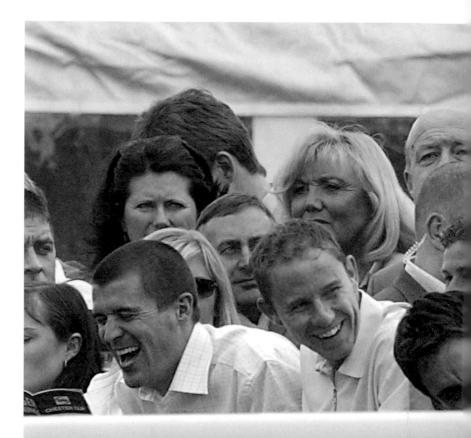

7th May, 2003
The following day and
Manchester United were
the Champions. The team
were together for a day
out at Chester races.
There were hordes of
other photographers
there. This was probably
one of the very last times
that he was out together
with the rest of team. In
the evening, they went by
coach to celebrate at the
Living Room.

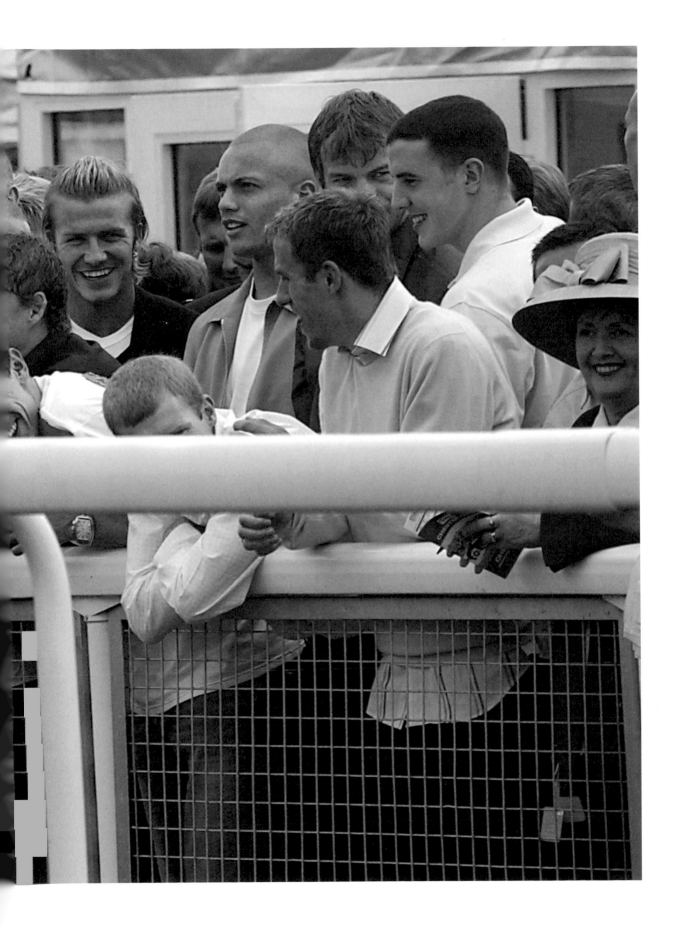

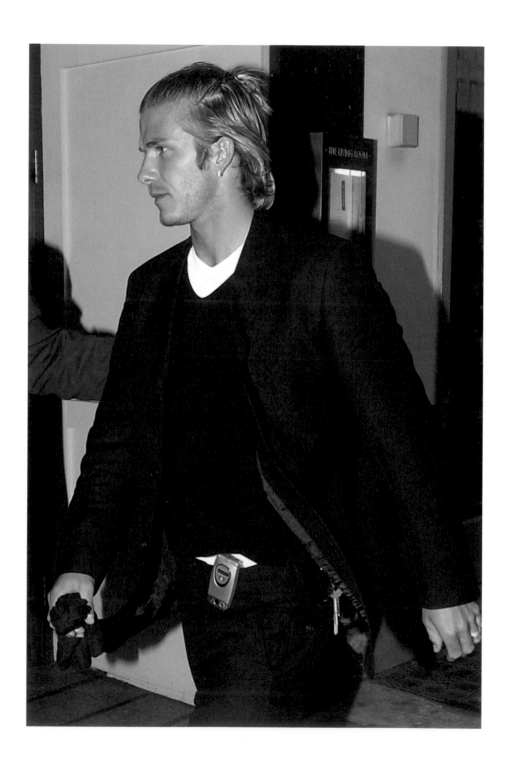

7th May, 2003.
After Chester races. Arriving at the Living Room.

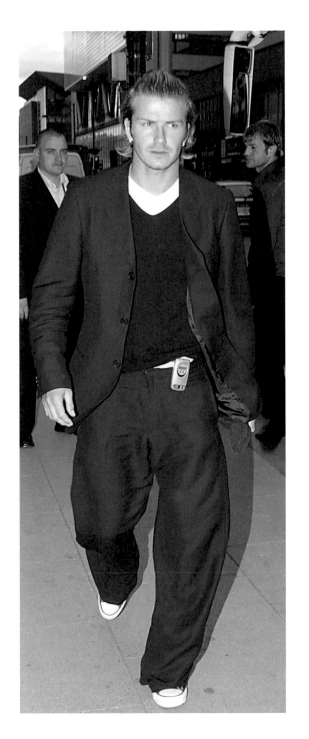
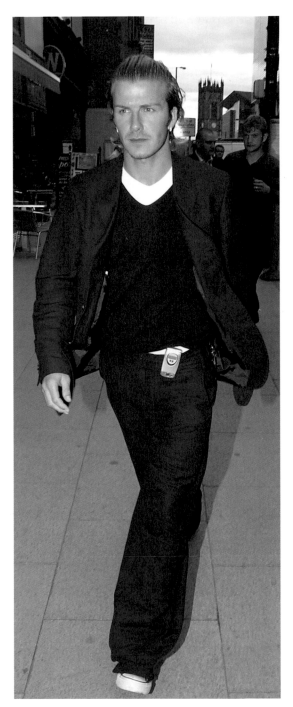

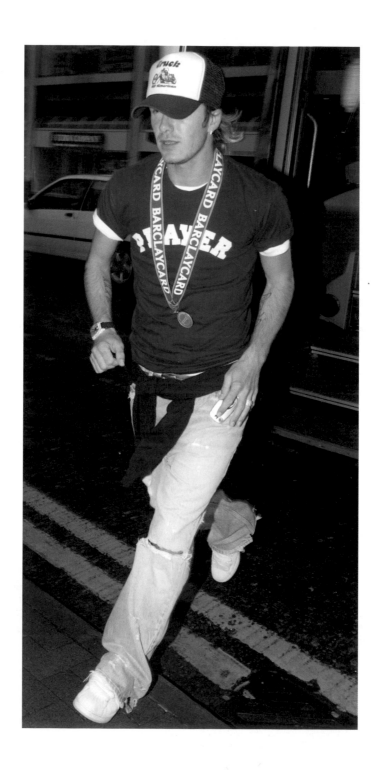

11th May, 2003
Arriving at the Living Room, with his Championship medal around his neck, for a team celebration after the final game of the season. His tattoos, by Middleton tattooist Louie Malloy, are visible. On one arm is the number seven written in Roman numerals, and on the other a small inscription with Victoria's name – written in Sanskrit. The photographs were used quite extensively. Note his t-shirt emblazoned with just the word 'player'.

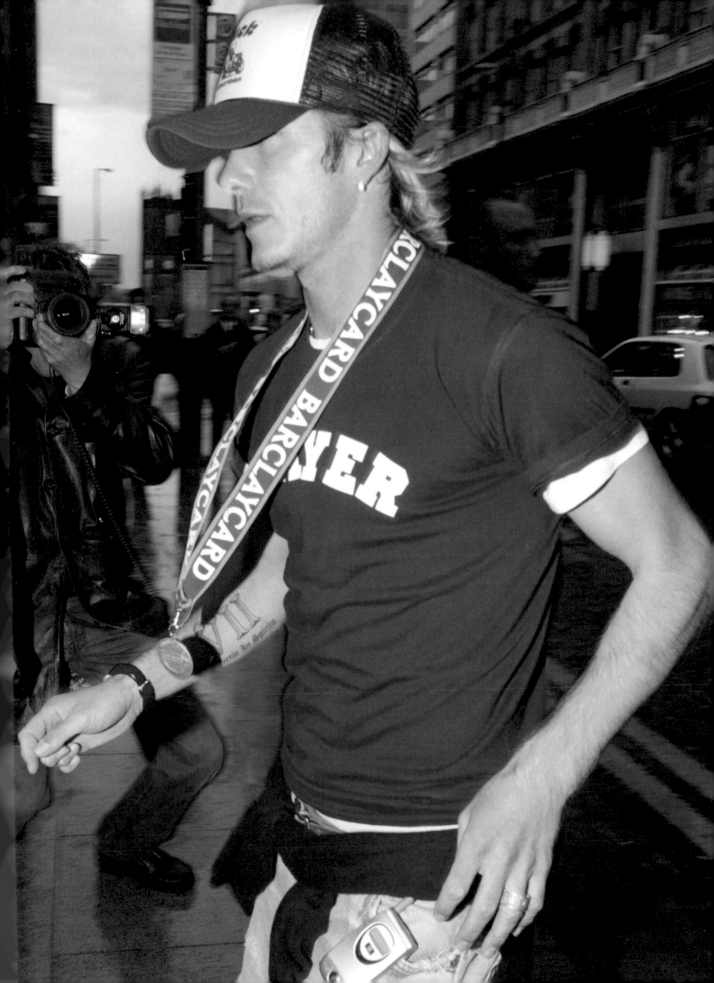

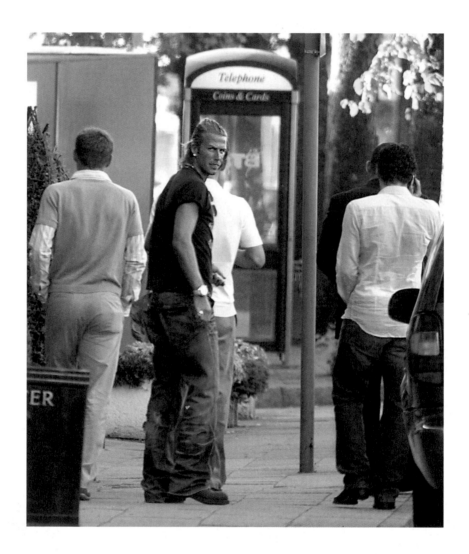

12th July, 2003
This was his first time back in Manchester after signing for Real Madrid. He was here for the wedding of his friend Dave Gardner to Davinia Taylor, and he and Phil Neville were to be the two best men. We headed down to Alderley Edge the evening before to have a look around, spotted the van that we knew he was being driven around in, and followed it to The Restaurant Bar and Grill in Alderley Edge. It was about 8.15pm when we took the photograph. In reality we shouldn't have been able to get this picture, the light was beginning to go and we were in a pretty bad position, on the wrong side, and too far behind. For some unknown reason though, he just stopped, turned and looked straight into the camera. The photo was sold exclusively to the *News of the World* for use on the Sunday – the day before the wedding. It took us about fifteen minutes to wire it to them, they decided they wanted it, paid us for exclusive use, but then only used it very small. A little bizarre, but it happens.

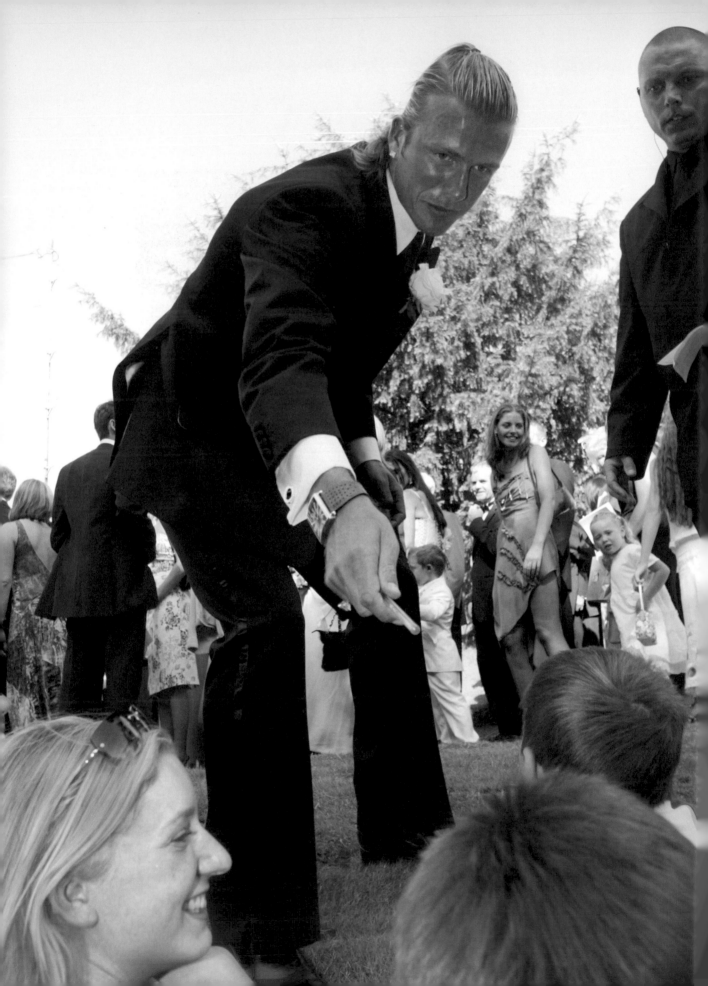

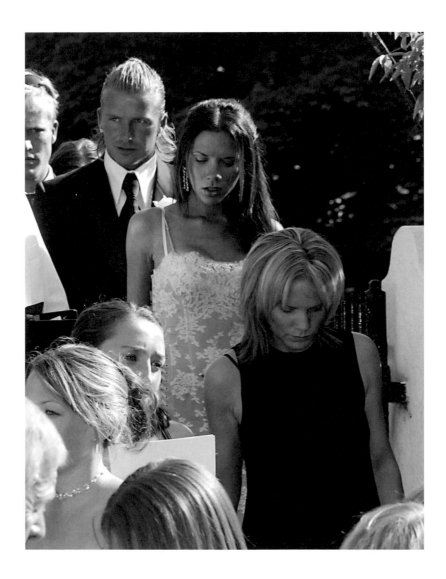

13th July, 2003. Dave Gardner and Davinia Taylor's wedding in Chelford, Cheshire.
There was a large press pack, probably 30 photographers as well as film crew. Victoria was there, along with her sister, Louise, and they arrived with Brooklyn. The crowd was amazing and David and Victoria signed autographs for everyone. They also posed for photographs, though their bodyguard who lives with them in Spain was with them all the time. It was a nice day, actually, a very hot day. The picture above shows David, Victoria, and her sister Louise – in the black dress. I did a print of that as a present for Davinia, and she loved it. She's got all the wedding photos that we did.

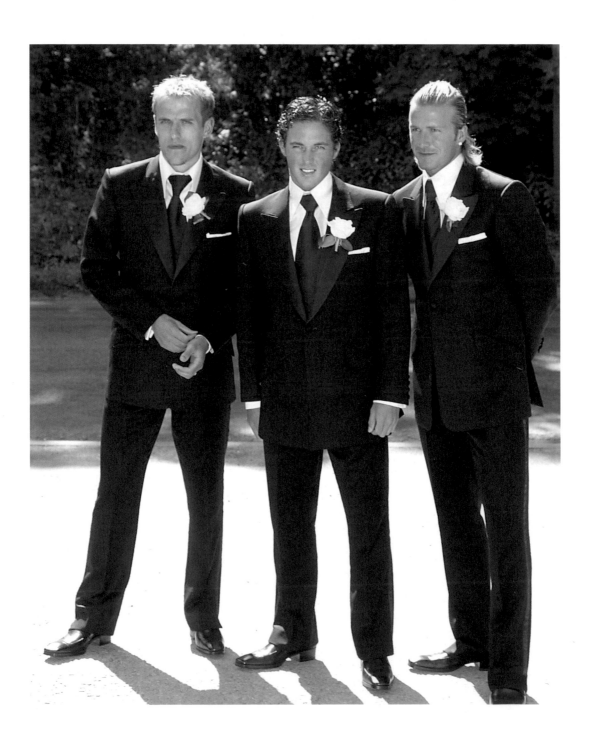

With bridegroom Dave Gardner, and with Phil Neville

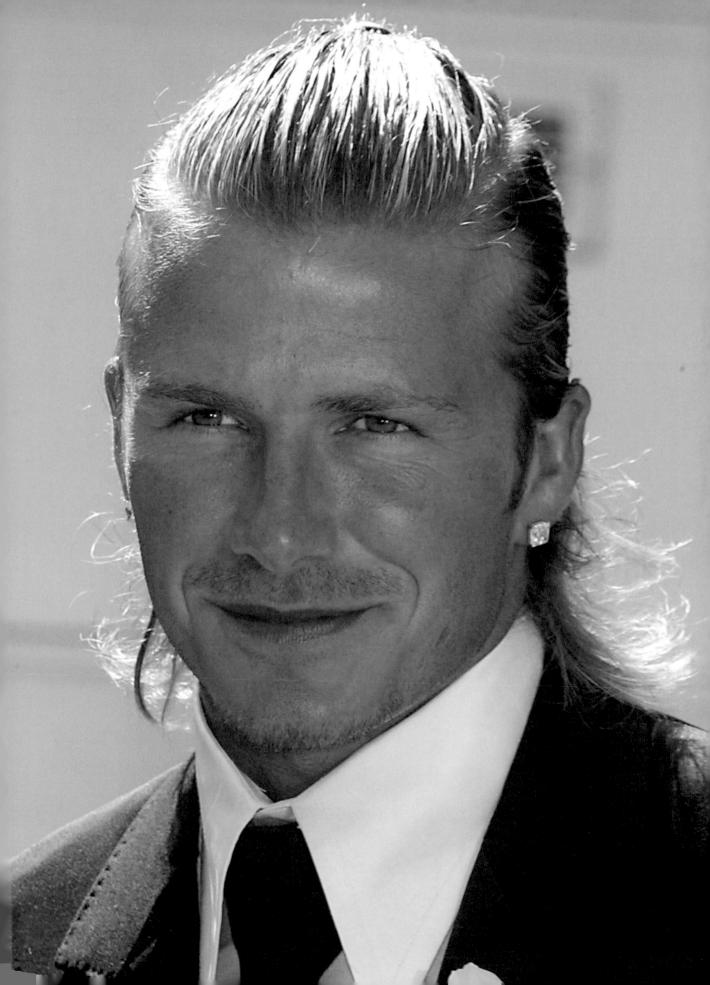

7th September, 2003
Harvey Nichols, Manchester.
Lunch in the restaurant
with Gary Neville and Dave
Gardner. Harvey Nichols
hadn't opened when he'd
left for Spain and so this
would have been his first
visit. We must have been
almost 100 yards away when
we took this picture.

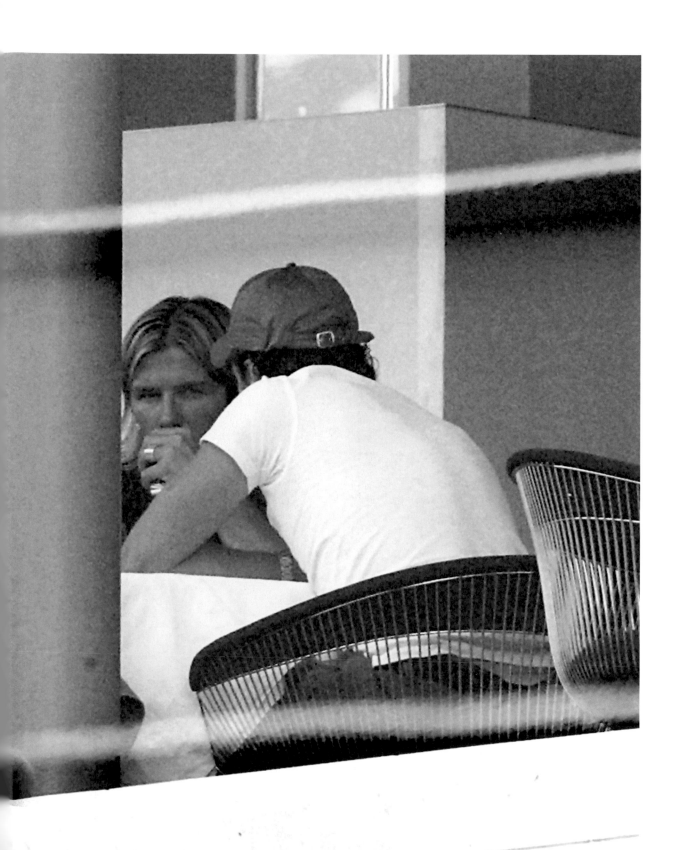

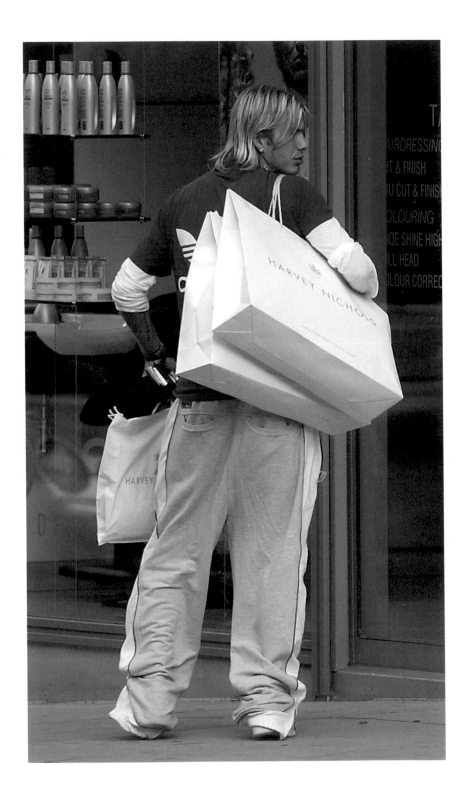

7th September, 2003
Leaving Harvey Nichols.

16th November, 2003
Back in Manchester again, for the England/Denmark match played at Old Trafford. He was leaving the Living Room after spending the evening with Gary Neville and Dave Gardner. As you'll see the two minders have got a new tactic – high-powered torches. The idea is to shine them straight into the lens of the camera, overexposing the shot so you don't get an image. Fortunately, we saw them take the torches in, so we knew what they'd planned, and we set the camera accordingly. Otherwise it would have worked. It doesn't make it easy for us and I can't see really see what I'm taking – it's as if you're shooting blind. Everyone's laughing – and the security guys think they've got an amazing new technique. But instead I've got some silly and rather surreal pictures of two grinning minders with torches and David Beckham laughing.

ACKNOWLEDGEMENTS

We would both like to thank the following people for their support.

Our mum Mary,
our dad John who died in 1990 before either of us became press photographers,
our brother Sean, his wife Lucy and their daughters Ellen and Nina,
our sister Bernadette and her boyfriend Steve,
and our brother Gary and his girlfriend Thora.

We also would like to thank James's girlfriend Karen and their daughter Olivia.

We both feel that we have been very lucky to have worked in Manchester where
some of the best photographers and writers in Journalism operate.

We would like to thank all the staff of the national newspapers and magazines
where our pictures have been published.

We would like to thank the staff of the *Manchester Evening News*,
especially those on the Picture Desk and the Diary.

We would also like to thank the many people who have provided us with
the information we needed to find and photograph our subjects,
you know who you are, but as agreed we will never name you.

And finally George.

Eamonn & James Clarke, May 2004